IMAGES
of America

AUSTIN'S
PEMBERTON HEIGHTS

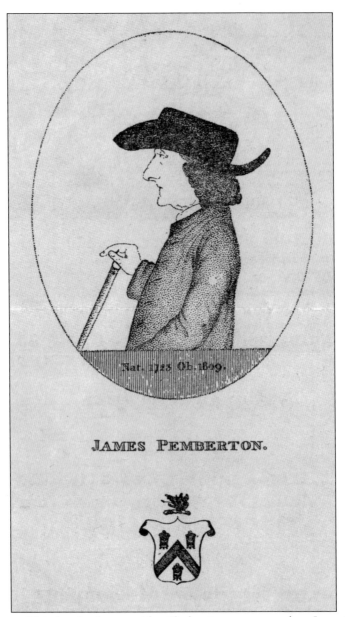

JAMES PEMBERTON. This drawing by an unidentified artist purports to show James Pemberton, an ancestor of Samuel "Budley" Fisher Jr. Fisher was one of the developers of Pemberton Heights. James Pemberton lived from 1723 to 1809 and participated in the American Revolution. "Pemberton" was thought to have an aristocratic sound, while "Heights" may refer to the limestone bluff upon which the neighborhood was built. (Courtesy of AHC/APL, AF-S6000[37]-001.)

ON THE COVER: QUINLAN CHILDREN. The Quinlan boys were photographed with their pet donkey at Splitrock, the oldest home in Pemberton Heights, about 1915. The view is looking east over the limestone bluff and creek that border the neighborhood. The boys' swing hangs from a live oak that, in 1976, would become an Austin Bicentennial Tree, measuring 16 feet, 10 inches in circumference, the eighth largest live oak in Austin. (Courtesy of the Tasch family.)

IMAGES
of America

AUSTIN'S
PEMBERTON HEIGHTS

Elizabeth A. Cash and
Suzanne B. Deaderick

ARCADIA
PUBLISHING

Published by Arcadia Publishing
Charleston, South Carolina

Printed in the United States of America

Library of Congress Control Number: 2012938151

For all general information, please contact Arcadia Publishing:
Telephone 843-853-2070
Fax 843-853-0044
E-mail sales@arcadiapublishing.com
For customer service and orders:
Toll-Free 1-888-313-2665

Visit us on the Internet at www.arcadiapublishing.com

To my husband, David, for his love and encouragement

—Elizabeth A. Cash

To David, Will, and Jake, for listening to all of my stories

—Suzanne B. Deaderick

CONTENTS

ACKNOWLEDGMENTS

The authors are grateful to the many people who helped them assemble a photograph collection to represent Pemberton Heights and who shared stories and leads about the interesting people who have lived there. Whenever possible, contributors were individually acknowledged next to their photographs. In addition, the following people contributed to the success of this book: Austin City Council members, for use of city photographs; Austin History Center staff, especially manager Mike Miller, for locating photographs and information; David P. Cash, for photograph scanning and much else; Candace Volz, for advice on history; Barton E. Cramer, for editing and encouragement; Raymond Lewis of Austin's First United Methodist Church; Jan Reed of Austin's University United Methodist Church; Margaret Fischer at the Texas Natural Science Center of the University of Texas at Austin; Elizabeth Haluska-Rausch at the University of Texas School of Law; Jeff Adams and Caitlin Bumford of the Texas Bar Archives; Susan Erickson, Adrienne Inglis, and Lynn Pugh Remadna for facilitating photographs and information; and Peggy Pickle, Leslie McConnico, Sally Baker, Desiree Durst and Ryan Botkin, Ann Greer Juul, J. Sam Winters, Clay Duckworth, and Barbara Clinton for historic information.

Photographs used with permission of the Austin Public Library's Austin History Center are indicated by "AHC/APL."

Pemberton Heights homes that have been granted historic landmark status by the City of Austin are indicated by "Historic Landmark." Whenever possible, old photographs of homes were used. Where those were not available, current photographs, taken by Suzanne Deaderick, have been included, so that this book may contribute to efforts to preserve the history of Pemberton Heights. In 2003, Pemberton Heights was placed in the National Register of Historic Places as part of the Old West Austin National Register Historic District.

All addresses, buildings, and landmarks referred to in this book are located in Austin, unless otherwise specified.

INTRODUCTION

Pemberton Heights is a residential neighborhood in Austin, which is located in Central Texas. One of the distinguishing features of homes in Pemberton Heights is their individuality. Many were architect designed. They were built in a variety of styles, with Tudor Revival and Colonial Revival being very popular. Other styles included Spanish Colonial, Monterey Revival, International, Streamline Moderne, Ranch, and Bungalow. Building materials are similarly varied. Wood or brick siding was often used. Important suppliers of lumber were Austin's Calcasieu Lumber Company and Brydson Lumber Company, while Elgin-Butler Brick provided brick for many Austin structures. Less often, cut limestone siding was used and, occasionally, stucco or asbestos. Tips Iron and Steel Company sometimes provided structural support and other metalwork.

Home building in Pemberton Heights began in the late 1920s, slowed during the Great Depression, but picked up again after the New Deal's Federal Housing Administration was formed in 1934 to encourage new home construction. Fortunately, Austin had many talented architects in the 1930s and beyond. Hugo Kuehne, Roy Thomas, Charles H. Page (and later PageSoutherlandPage), Harold "Bubi" Jessen, Ernest Parker, and Roy White were known for skillfully designing both homes—some in Pemberton Heights—and public buildings. Custom embellishments were provided by woodcarver Peter Mansbendel and ironworker Fortunat Weigl. Today, their work lends prestige and interest to several Pemberton Heights homes.

The western boundary of Pemberton Heights follows the tracks of a railroad that arrived in Austin in 1876. About 100 years later, a highway was built next to the tracks, further separating Pemberton Heights from Tarrytown, its neighbor to the west.

Windsor Road, named for Windsor, Connecticut, bounds Pemberton Heights to the south. The fifth and thirteenth governor of Texas, Elisha Pease, moved from Connecticut to Texas in 1835. Governor Pease lived in the Pease Mansion plantation home, whose land eventually became a part of Pemberton Heights and Old Enfield, the neighborhood to the south.

The northern boundary of Pemberton Heights blends with the neighborhood of Bryker Woods. In this book, the northern boundary of Pemberton Heights is Northwood Road from its intersection at the railroad, east to its intersection with Wooldridge Drive, then north on Wooldridge Drive to West Twenty-ninth Street and east along West Twenty-ninth Street to the Twenty-ninth Street Bridge.

Pemberton Heights is bounded on the east by Shoal Creek. The limestone bluffs of the creek elevate the neighborhood more than 100 feet above downtown, allowing glimpses of the University of Texas Tower and the state capitol to the east. Shoal Creek originally formed a natural barrier to Austin's westward expansion, especially because it was prone to flooding and washing out bridges. In the 1920s, however, two permanent bridges were built across the creek, making the development of Pemberton Heights possible. A third bridge was added in about 1935.

The first section of Pemberton Heights was laid out in 1927 by Koch & Fowler, consulting engineers, using principles from the City Beautiful movement. At the same time, the firm was creating a city plan for Austin. Koch & Fowler eventually would plan more than 30 Texas cities.

Wooldridge Drive, which curves along the south and east sides of the neighborhood, was named for one of Austin's mayors. The southern half of Wooldridge Drive was platted in 1927 as one of the earliest neighborhood streets. It was subsequently extended to the north in 1938, joining another segment of road that originally had been called Splitrock Avenue but was renamed Wooldridge. Wooldridge Drive is the location of one of the most unusual and best-known homes in Pemberton Heights, "the castle." Green Lanes is a small spur off the southern end of Wooldridge Drive. Pemberton Place is one of two cul-de-sacs in Pemberton Heights; it branches off from Wooldridge Drive as well. It was not developed until 1945. As previously noted, West Twenty-ninth Street marks the northern edge of the neighborhood, and Wooldridge Drive terminates there. There are various lot sizes along these streets, some of which were necessitated by the slope toward Shoal Creek and some of which were purposefully planned to give the neighborhood visual interest and to appeal to a broad market.

Harris Boulevard and Hardouin Avenue were platted in 1927 and thus also were among the earliest streets to be developed in Pemberton Heights. Wathen Avenue was platted in 1936, and McCallum Drive followed in 1938. These streets are located in the southeastern portion of the neighborhood. The main entrance to Pemberton Heights is considered to be Harris Boulevard at Windsor Road. Harris Boulevard was named after Judge John Woods Harris, who was Governor Pease's law partner and who bought the land that would become Pemberton Heights from Pease in 1859. Harris Boulevard is slightly wider than its cross streets and it is the only street in Pemberton Heights called a boulevard. Wathen Avenue was named for Lucille Wathen Fisher, whose husband was one of the original developers of the neighborhood. McCallum Drive was named in honor of husband and wife Arthur and Jane McCallum. Arthur was superintendent of the Austin Public School System for 39 years. Jane was Texas secretary of state under Gov. Dan Moody in 1927.

Ethridge and Gaston Avenues east of Harris Boulevard were platted in 1938 and west of Harris Boulevard in 1940. Moving north, Preston Avenue was platted in pieces in 1937, 1938, and 1940. Unlike the more curving streets to the south, Ethridge, Gaston, and Preston Avenues mark where the streets become straighter and the lots more uniform in size. This is an indicator of the shift from the City Beautiful development ideals to the post–World War II building boom.

Claire Avenue connects Gaston Avenue with Wooldridge Drive and was platted in 1935. Gaston and Claire Avenues were named for P. Gaston Dismukes and Claire Caswell. Claire and Gaston married in 1910. Less than a year later, Gaston died of tuberculosis. Claire eventually remarried. Only two days after the wedding, Claire died when the ship on which she and her second husband were honeymooning sank. W.T. Caswell honored his sister Claire and friend Gaston by naming intersecting streets for them when he subdivided this portion of Pemberton Heights. Both streets back onto Shoal Creek, and the lots are configured accordingly.

On the west side of the neighborhood, Jarratt Avenue runs north from Windsor Road until it ends at Gaston Avenue. The southern portion of Jarratt Avenue was developed in 1927 and the northern portion in 1936. Jarratt Avenue was named for J.E. Jarratt, who was chairman of the board of the Austin Development Company, which first developed the neighborhood.

Westover and Northwood Roads and Oakhurst Avenue comprise a narrow subdivision called Edgemont that runs the width of the north end of Pemberton Heights. Edgemont, likely named for a plantation that existed nearby until 1957, was platted in 1927. Its streets contain more modest homes than those found in the southern part of the neighborhood. Westover Road was probably given its name because it travels west, over a hill. People such as salesmen, stenographers, clerks, state employees, students, and managers rented or lived in the bungalows in the north end of the neighborhood. Throughout Pemberton Heights, many of the home buyers were associated with the University of Texas or the state government. Some were renowned politicians and professors. Still others owned or managed businesses that were among the mainstays of Austin when downtown was the place to shop and Pemberton Heights was on the edge of town.

One

BOUNDARIES AND BRIDGES

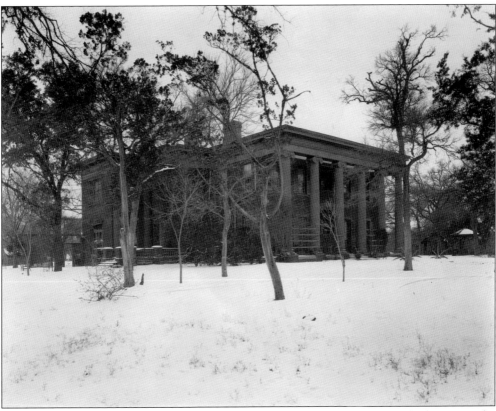

WOODLAWN. Taken on October 27, 1927, this photograph shows Woodlawn, also known as the Pease Mansion, at 1606 Niles Road under a rare blanket of snow. The land upon which Pemberton Heights was built, beginning in 1927, was originally part of the plantation surrounding the Pease Mansion. The mansion was designed and built by famed architect Abner Cook in 1853 and sold to Texas governor Elisha Pease and his wife, the former Lucadia Christiana Niles of Poquonock, Connecticut, in 1856. (Courtesy of AHC/APL, PICH02146.)

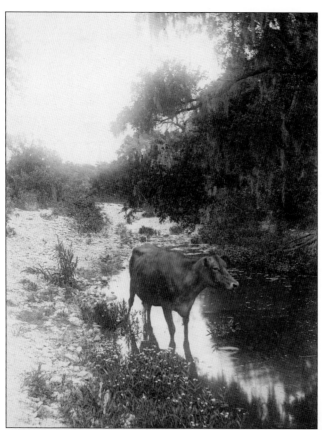

SHOAL CREEK WITH COW. Shoal Creek marks the eastern border of Pemberton Heights. The creek gets its name from the rocky shoals that dotted its shallow course to the Colorado River (now Lady Bird Lake). This undated photograph shows Shoal Creek as an idyllic rivulet with its rocky limestone bed and overhanging trees. (Courtesy of AHC/APL, PICA04571.)

SHOAL CREEK, DONKEY, AND BOYS. This photograph was taken around 1915, before Pemberton Heights was developed. These boys, who lived at Splitrock (see page 43) from about 1911 to 1938, are enjoying a ride along Shoal Creek on their donkey. Because Pemberton Heights originally was outside the city of Austin, some early residents kept barnyard animals for pets. (Courtesy of the Tasch family.)

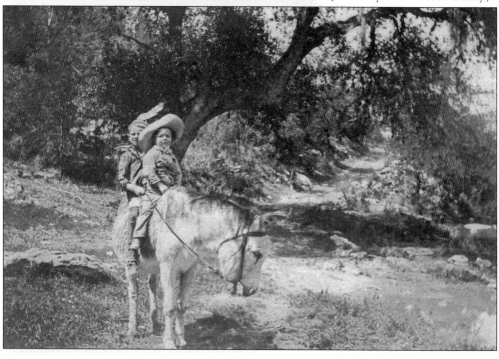

SHOAL CREEK RECREATION, 1896.
This 1896 photograph of two boys,
possibly hunting, shows them at the
entrance to Splitrock, a cleft that
marked one of Shoal Creek's many
swimming holes. In the 1890s, the
banks of Shoal Creek near Splitrock
were the focus of secret, nocturnal
hunts for legendary buried Mexican
treasure, with the treasure-seekers
leaving holes and mounds of dirt behind.
(Courtesy of AHC/APL, PICA13827.)

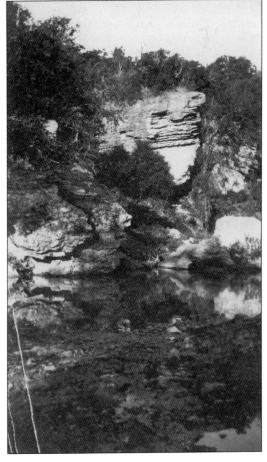

SPLITROCK SWIMMING HOLE. Splitrock,
Blue Hole, and Cat Hole were popular
swimming spots along Shoal Creek for
many years. From 1865 to 1866, Gen.
George Custer was headquartered at the
Pease Mansion (see page 9). Some of
his soldiers camped along Shoal Creek
in a tent city, and undoubtedly they
enjoyed the recreational opportunities
offered by the swimming holes.
(Courtesy of the Tasch family.)

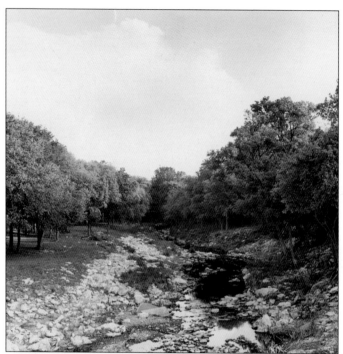

SHOAL CREEK, MARCH 1975. The Shoal Creek greenbelt, known as Pease Park, got its start in 1875, when Governor and Mrs. Pease (see page 9) donated land along the creek bank, the first donation of this kind in Texas. In 1929, the City of Austin bought additional land along the creek. Goodall Wooten and others donated land along the creek east of Pemberton Heights to connect and extend the greenbelt. (Courtesy of AHC/APL, PICA09804.)

JANET FISH, SHOAL CREEK PRESERVATIONIST. In 1952, Janet Long Fish, shown here as a girl with her father, Walter Long, decided that the Comanche trail alongside Shoal Creek should be preserved as a walking path. For four years, she led a city bulldozer in grading the trail, tossing her hat in the air at intervals so the bulldozer operator could spot her through the tall weeds. (Courtesy of J. Chrys Dougherty III and Molly I. Dougherty.)

WINDSOR ROAD, 1934. Windsor Road, which crosses Shoal Creek, marks the southern boundary of Pemberton Heights and served as the first major road to bring potential buyers from Austin to the neighborhood. Pemberton Heights is on the north side of Windsor Road, while another neighborhood, named Old Enfield, had begun development around the Pease Mansion on the south side of the road about a decade earlier. (Courtesy of AHC/APL, PICA24960.)

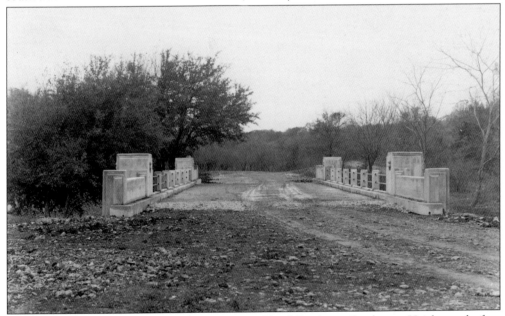

GASTON AVENUE BRIDGE. This bridge crosses over Shoal Creek into Pemberton Heights at the foot of Gaston Avenue. Today, it is not used as often as the Windsor Road and Twenty-ninth Street Bridges and remains a two-lane bridge. It was featured in the July 1935 issue of the professional journal *Civil Engineering* because of the interesting methods that were used to solve certain design problems. (Courtesy of AHC/APL, PICA18951.)

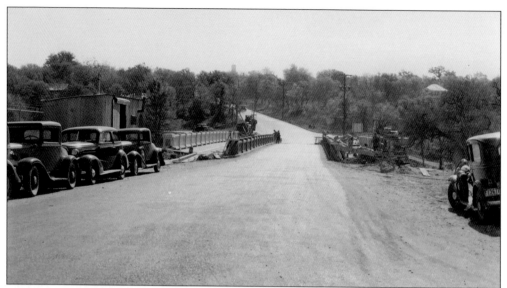

WINDSOR ROAD BRIDGE DURING WIDENING. Built in July 1928 in only 28 days, this bridge brought potential home buyers across Shoal Creek to Pemberton Heights. It incorporates a difficult decorative concrete technique and was considered one of the most beautiful bridges in Texas. In 1939, the bridge was widened to four lanes. The original bridge is still visible in this photograph, taken during the enlargement. (Courtesy of AHC/APL, PICA18944.)

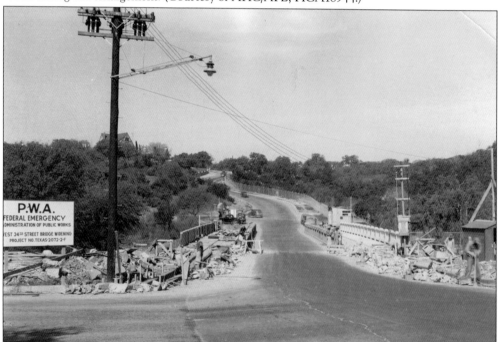

WINDSOR ROAD BRIDGE, LOOKING WEST. The Windsor Road Bridge widening was a Public Works Administration project stemming from the Great Depression, as the sign shows. In this 1939 photograph, the photographer had Pemberton Heights over the bridge in front of him and to the right and Austin behind him. A home in Old Enfield can be seen on the left side of the road. (Courtesy of AHC/APL, PICA19038.)

14

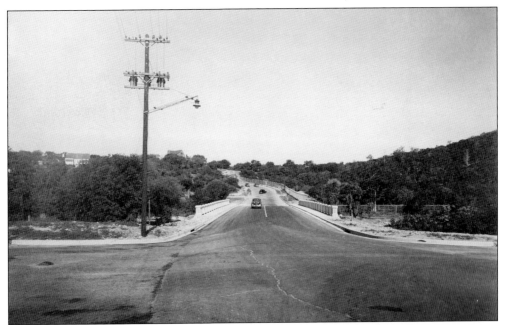

WINDSOR ROAD BRIDGE, WEST. This photograph was taken in 1939 after the widening project was complete, as comparison with the previous photograph will show. The photographer was standing in almost the same place. As is true today, a steady stream of automobiles uses the bridge to cross Shoal Creek and access what is now west Austin. (Courtesy of AHC/APL, PICA02415.)

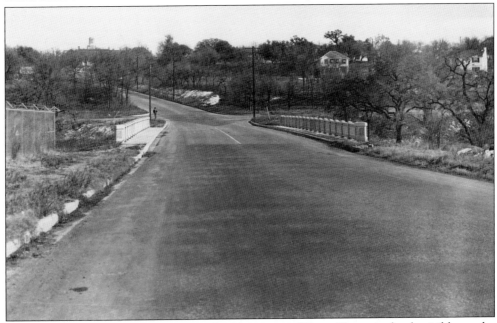

WINDSOR ROAD BRIDGE, LATE 1939. The University of Texas Tower is clearly visible on the horizon in this 1939 photograph. In 1988, the city planned to demolish the bridge in order to widen Windsor Road to six lanes. Many citizens, including US senator Ralph Yarborough (see page 96), lobbied to preserve the bridge, and it was given protected city historic landmark status that year. (Courtesy of AHC/APL, PICS18943.)

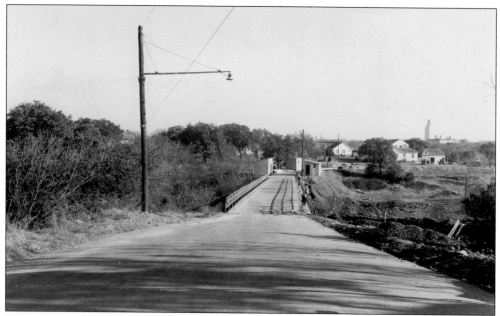

WEST TWENTY-NINTH STREET BRIDGE BEFORE RECONSTRUCTION. On the north end of Pemberton Heights, a modest steel-frame and wood-plank bridge, which predated the neighborhood, spanned Shoal Creek. This bridge was replaced with a concrete bridge in 1926, which in turn had to be repaired in 1933. This photograph shows the 1933 bridge as it appeared in 1939. The photographer is looking east out of Pemberton Heights. (Courtesy of AHC/APL, PICA02070.)

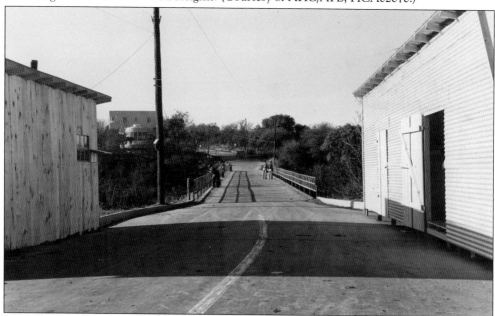

WEST TWENTY-NINTH STREET BRIDGE, CONSTRUCTION SHEDS. The West Twenty-ninth Street Bridge was replaced in 1939 as part of a Public Works Administration project. This January 10, 1939, photograph is looking into Pemberton Heights and shows the old bridge, sheds erected for the reconstruction project, and the historic Bohn House on the horizon to the left. (Courtesy of AHC/APL, PICA02069.)

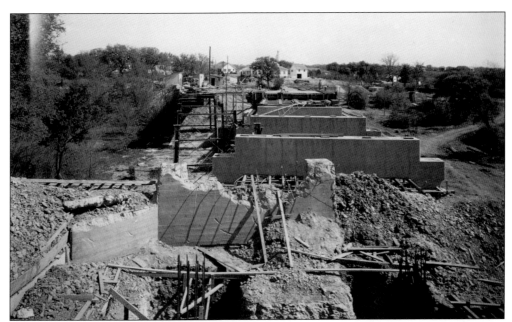

WEST TWENTY-NINTH STREET BRIDGE DURING RECONSTRUCTION. The Public Works Administration bridge reconstruction was well underway in this March 23, 1939, photograph. The project improved the safety of the bridge by straightening the approaches and also increased the bridge's capacity. The photographer is looking east out of Pemberton Heights, toward Austin and the University of Texas. (Courtesy of AHC/APL, PICA02076.)

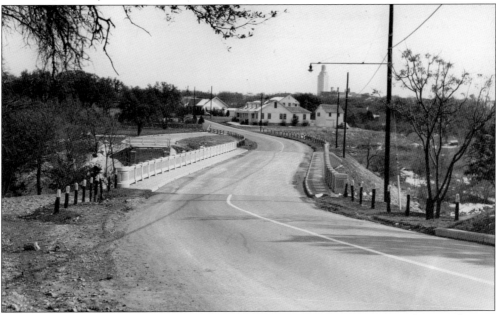

WEST TWENTY-NINTH STREET BRIDGE AFTER RECONSTRUCTION. By January 25, 1940, the new bridge was finished and ready to welcome automobile drivers to Pemberton Heights. A remnant of the old bridge, with its dangerous curving approach, had yet to be removed. This photograph looks east out of the neighborhood, with the University of Texas Tower easily visible on the horizon. The bridge looks like this today. (Courtesy of AHC/APL, PICA19040.)

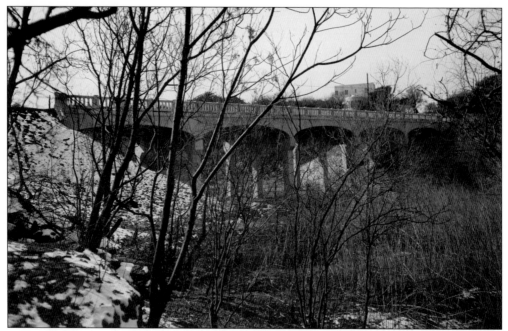

WEST TWENTY-NINTH STREET BRIDGE, NORTH ELEVATION. This January 25, 1940, photograph shows the north face of the new bridge. The underside of the bridge reveals its concrete girder T-beam construction and attractive concrete vaulting. Just over the bridge, the Bohn House is visible. Today, a walking path goes under the bridge, along Shoal Creek. (Courtesy of AHC/APL, PICA18945.)

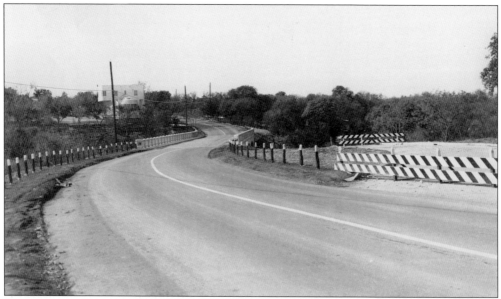

WEST TWENTY-NINTH STREET BRIDGE, LOOKING WEST. Another photograph in the series taken on January 25, 1940, to document the completion of the project looks into Pemberton Heights across the new bridge. The old road leading to the partly demolished former bridge is barricaded. The Bohn House serves as a landmark structure for drivers entering the neighborhood. (Courtesy of AHC/APL, PICA02077.)

WEST TWENTY-NINTH STREET, BRYKER WOODS. Pemberton Heights was not the only new development to benefit from the West Twenty-ninth Street Bridge project. The neighborhood of Bryker Woods was being built immediately to the north of Pemberton Heights, as the sign at the end of West Twenty-ninth Street shows. This photograph was taken in 1940. (Courtesy of AHC/APL, PICA19039.)

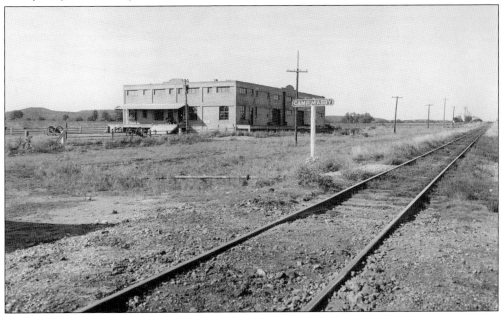

RAILROAD DEPOT. The western boundary of Pemberton Heights is marked by the tracks of the former International & Great Northern Railroad (I&GN), which reached Austin in 1876. In 1925, the railroad became part of the Missouri Pacific Railroad (MoPac). This 1915 photograph shows the I&GN depot at Camp Mabry, less than a mile north of Pemberton Heights. (Courtesy of AHC/APL, C00741.)

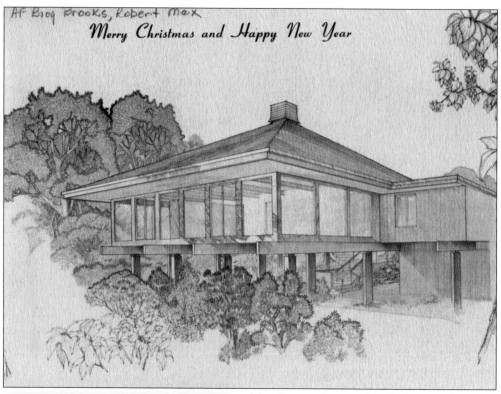

Merry Christmas and Happy New Year

MAX BROOKS HOUSE. Nestled among the trees at 1500 West Twenty-fourth Street and designed by Max Brooks, this house sits at the corner of Twenty-fourth Street and Pemberton Parkway on the edge of Pemberton Heights. It was built in 1964 for Max and Marietta Brooks. Max started his Austin architecture practice in 1936 and became associated with Fredrich Giesecke and Hugo Kuehne in 1942. He was partner in charge of many significant projects, including the US embassy in Mexico City, the new Department of Labor building in Washington, DC, and the LBJ Library in Austin. (Courtesy of AHC/APL, Brooks, Robert Max-001.)

R. MAX BROOKS. A former Navy lieutenant, Max Brooks played a large role in the great 1969–1971 battle to save Austin's historic Driskill Hotel from demolition. Greatly influencing his career was close friend Commodore E.H. Perry. The two planned and carried out many projects, which contributed to the development of the city of Austin, including the 1951 Perry-Brooks Building downtown at Seventh and Brazos Streets. (Courtesy of APL/AHC, PICB01120.)

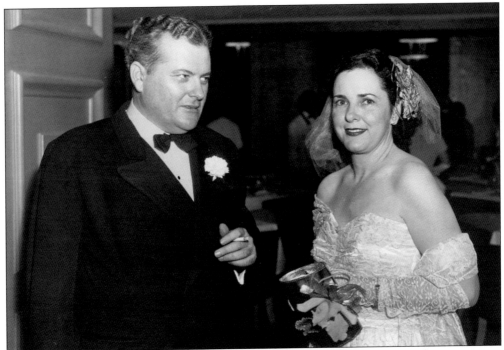

MAX AND MARIETTA MOODY BROOKS. Shown here are Max and Marietta Brooks at their wedding. Marietta was one of 48 women chosen from across the nation to advise the Defense Department on policies regarding women in the services. The Brookses were close friends of Lyndon B. Johnson and had a presidential sink from the White House installed in their bathroom. The sink is still in use in the house today. (Courtesy of AHC/APL, PICB01119.)

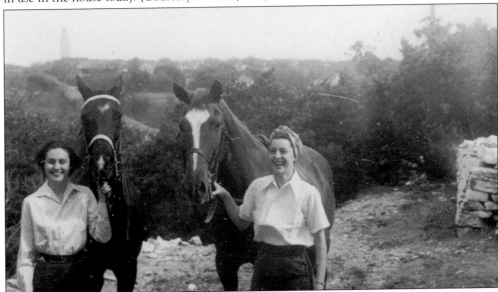

RIDING INTO TARRYTOWN. Over the railroad tracks to the west of Pemberton Heights, a neighborhood called Tarrytown would eventually be developed with the help of a building boom after World War II. Before there were too many houses, friends Mary Ireland Graves (left) and Janet Long (see page 12) used to ride horses there. (Courtesy of J. Chrys Dougherty III and Molly I. Dougherty.)

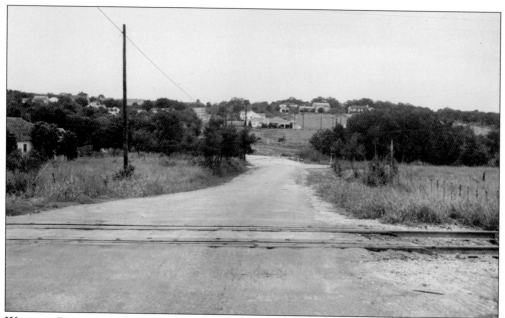

WINDSOR ROAD AT MOPAC. The intersection of Windsor Road and the MoPac Railroad tracks, located at the southwest corner of Pemberton Heights, was photographed on August 28, 1945. The photographer is looking west into Tarrytown. In the 1940s and 1950s, the Austin City Council developed plans to create a boulevard beside the train tracks. (Courtesy of AHC/APL, PICA18218.)

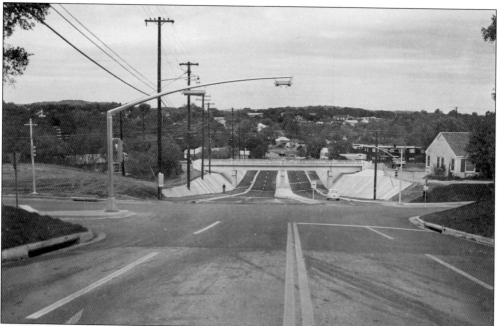

MOPAC EXPRESSWAY. This is an interesting update to the previous photograph. It is a very similar view approximately 30 years later. The tree-lined boulevard that had been planned to run along the MoPac tracks from Town Lake to Northland Drive was never built. Austin was growing, and a highway was begun, amidst much controversy, in 1975. (Courtesy of AHC/APL, PICA02416.)

Two

WOOLDRIDGE DRIVE, WEST TWENTY-NINTH STREET, GREEN LANES, AND PEMBERTON PLACE

ALEXANDER PENN WOOLDRIDGE. Wooldridge Drive was named for A.P. Wooldridge, who was mayor of Austin from 1909 to 1919 and was Samuel "Budley" Fisher Jr.'s uncle. Fisher was one of Pemberton Heights' developers. Wooldridge received Austin's first Most Worthy Citizen award in 1924. He organized the Austin Public School System, secured Austin as the location for the University of Texas, and visualized a series of dams along the Colorado River to benefit the town. (Courtesy of AHC/APL, PICB11161.)

Looking South on Wooldridge Drive. This photograph shows the west side of the 2500 block of Wooldridge Drive, between Gaston and Hardouin Avenues, looking south. The middle house was owned by Vernon A. McGee (see page 33), who was instrumental in organizing the Texas Employment Commission. (Courtesy of AHC/APL, PICA02419.)

Looking North on Wooldridge Drive. Moving south from the location of the previous photograph and turning to look north, the photographer captured more of the 2500 block of Wooldridge Drive. Most of these houses have maintained their historic appearance with only minor changes to the exteriors. (Courtesy of AHC/APL, PICA02418.)

JOSEPHINE LUCILLE WATHEN FISHER. Known as Lucy, Josephine married Budley Fisher in 1905. Budley was the owner of the land that became Pemberton Heights. He deeded Lucy 137 acres in 1925. Upon their divorce, she sold her property to the Austin Development Company, of which Budley was president, in exchange for shares of the corporation and a place on the board of directors. Wathen Avenue is named for her. (Courtesy of AHC/APL, PICB02822.)

THE JOSEPHINE FISHER HOUSE. After her divorce from Budley Fisher in 1927, Josephine built this Spanish Colonial–style house at 1505 Wooldridge Drive on land she reserved from the sale of her property to the Austin Development Company. Lucy lived here with her four sons until 1942, when she rented out the main house and moved to the garage apartment in the back. She sold the property in 1949. (Historic Landmark.) (Photograph by Suzanne Deaderick.)

THE GREENWOOD AND NINA WOOTEN HOUSE. Greenwood and Nina Wooten lived at 1405 Wooldridge Drive. Dr. Thomas D. Wooten, Greenwood's grandfather, was among the planners who enabled the University of Texas to open in 1884. He was also a member of the first board of regents. Greenwood's uncle was Goodall Wooten, after whom Wooten Elementary and the University of Texas's Goodall Wooten Dormitory are named. (Historic Landmark.) (Photograph by Suzanne Deaderick.)

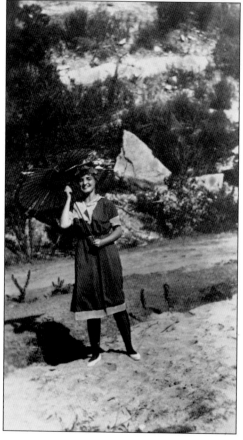

NINA BELLE PAYNE WOOTEN. Nina Belle is shown here in a 1915 photograph taken on Bull Creek. Nina was the daughter of C.W. and Rose Payne, both native Texans. C.W. Payne was the vice president of the Merchants and Planters Cotton Mill in San Antonio. Nina attended the University of Texas before marrying Greenwood. They had one son, Dr. Greenwood Wooten Jr. (Courtesy of AHC/APL, PICB10098.)

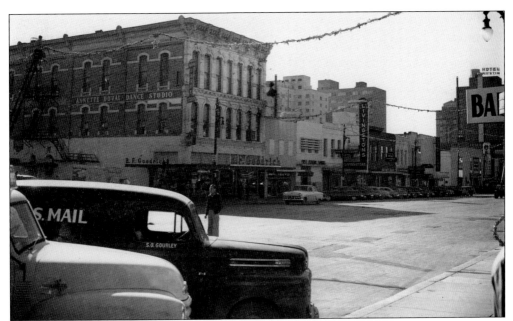

GREENWOOD DRUG COMPANY. In August 1921, Greenwood Wooten established the Greenwood Drug Company at 922 Congress Avenue. The store can be seen in the far right of the picture. Wooten's business expanded rapidly, and he opened a second store at Twenty-sixth and Guadalupe Streets with "free delivery—anywhere, anytime." Wooten owned and operated the Greenwood Drug Company for 30 years. (Courtesy of AHC/APL, C03385.)

SMITH HOUSE. Designed by noted architect Roy Thomas and built about 1938, this was the home of Herbert and Gladys Smith at 1502 Wooldridge Drive. Herbert was counsel for Texas railroad companies before becoming a partner in the law firm of Smith-Rotsch-Steakley. (Courtesy of AHC/APL, AR.2009.036[002].)

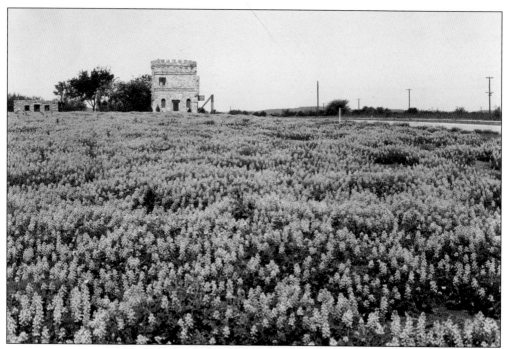

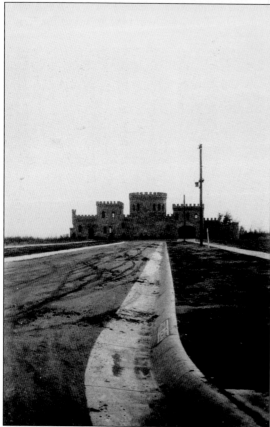

THE CASTLE, C. SPRING 1928. In 1927, the Austin Development Company converted an old water tower at 1415 Wooldridge Drive to a "castle," which served as the Pemberton Heights land office, as the sign on the side of the building says. The tower previously had been used for firefighting and later for watering crops on the surrounding farmland. Nurses from a nearby state school used to swim in the water tower. (Historic Landmark.) (Courtesy of AHC/APL, PICH05630.)

THE CASTLE, 1930s. Cut limestone wings were added to the original tower structure shown in the previous photograph. Because of the Depression, by 1932, ownership of the castle had transferred to the American National Bank of Austin, which installed the J.F. Kone family as caretakers and the castle's first residents. In 1935, the bank tried unsuccessfully to sell the castle for $8,000. For more about the tiled street sign visible in this photograph, see page 79. (Courtesy of AHC/APL, PICH04968.)

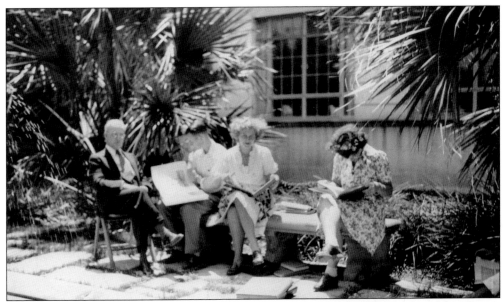

Prof. Samuel Gideon. Professor Gideon, far left, is shown here teaching a watercolor class in about 1945. Gideon, an architect, purchased the castle in 1937. He used bricks and stained-glass windows from the original University of Texas Main Building, demolished in 1934, to enhance the castle. He also incorporated a purported Peter Mansbendel staircase from the Bishop Kinsolving residence. Gideon died in 1945, and his wife, Sadie, died at the castle in 1954. (Courtesy of AHC/APL, PICB14373.)

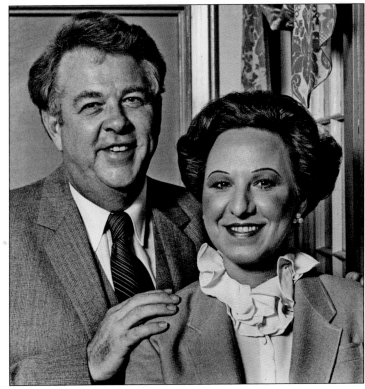

William and Margaret Kilgarlin. The Kilgarlins were later residents of the castle. Bill Kilgarlin was elected to the Texas House of Representatives in 1958. He filed the lawsuit *Kilgarlin v. Martin*, which required the State of Texas to adopt single-member voting districts for the legislature. Kilgarlin was elected to the Supreme Court of Texas in 1982. He and his wife are shown here in 1981. (Courtesy of Texas Bar Journal Photo Files, Archives of the State Bar of Texas; copyright Peter A. Silva, with permission.)

29

PROF. PAUL THOMPSON. Thompson was called the "Godfather of Journalism" in Texas, and his pioneering efforts led to the establishment and growth of the School of Journalism at the University of Texas. One of his proudest achievements was the construction of the new journalism building on the university's campus. In 1966, Paul Thompson and DeWitt Reddick (see page 106) were honored by the University of Texas Board of Regents with an endowment to benefit the College of Communications. (Courtesy of AHC/APL, PICB09144.)

THE PAUL THOMPSON HOUSE. Built in 1937 by Roy Thomas for Paul and Bess Thompson, this house is located at 1507 Wooldridge Drive. For 31 years, the School of Journalism at the University of Texas was the center of Paul Thompson's professional life. Paul and Bess lived in the house during those years. (Historic Landmark.) (Courtesy of AHC/APL, AR.2009.036[002].)

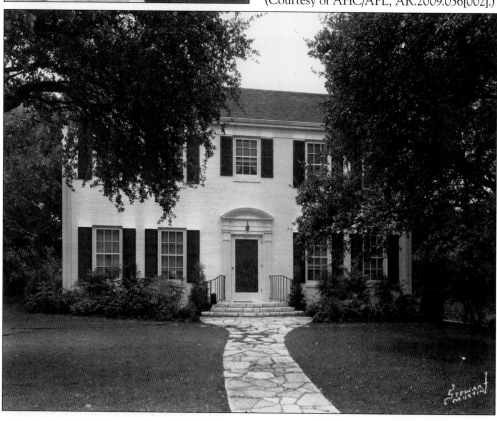

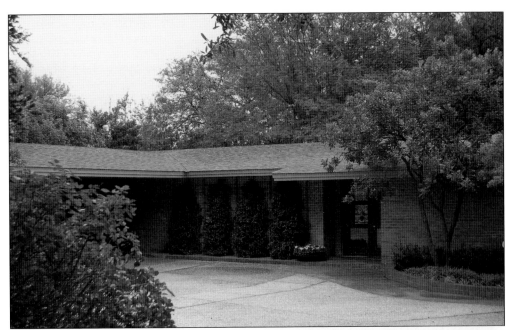

RUEL WALKER HOUSE. This Mid-century Modern house at 2419 Wooldridge Drive was designed by the Dallas architectural firm of Beran-Shelmire for Judge and Mrs. Ruel Walker in 1960. Beran-Shelmire designed the Dallas Loews Anatole Hotel and also did the exquisite renovation and restoration of the Adolphus Hotel and French Room, also in Dallas. Local contractor A.C. Warner built the house. It is the only house in Austin known to have been designed by Beran-Shelmire. (Photograph by Suzanne Deaderick.)

JUDGE RUEL WALKER. Ruel Walker was appointed by Gov. Allan Shivers to the Texas Supreme Court in 1954, where he served until 1976. The Walker family lived at 2419 Wooldridge Drive for 44 years. Walker's wife, Virginia, was very artistic and began designing Christmas cards for friends and family at the age of 16; many of these are preserved at the Austin History Center. Virginia and Ruel are buried in the Texas State Cemetery. (Courtesy of Ruel Walker Jr.)

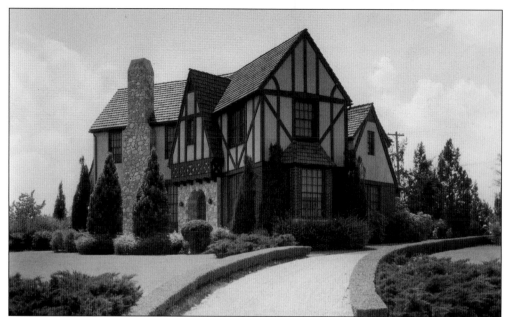

A.E. WOOD HOUSE. Dated May 14, 1936, this photograph shows the front entrance of the home at 2424 Wooldridge Drive. It was built in 1931 for Ashley E. Wood and his wife, Mattie Beth. Wood was elected to the Texas Senate in 1919. In 1923, he was hired by the Ku Klux Klan to defend a Klansman who had committed a hate crime. Wood's opposing attorney in the trial was future Texas governor Dan Moody, who prevailed in court. (Courtesy of AHC/APL, C01526.)

WOOD HOUSE, SIDE VIEW. Ashley Wood eventually became chairman of the powerful Texas Senate Appropriations Committee. He used his influence to increase the size of the University of Texas from the original 40 acres to close to its present size. He also created what would become the Texas Department of Parks and Wildlife. The A.E. Wood Fish Hatchery in San Marcos is named for him. (Courtesy of AHC/APL, C01528.)

ORIGINAL VERNON MCGEE HOUSE. Located at 2512 Wooldridge Drive, this house was built for Vernon and Janice McGee. McGee was assistant director of the Texas Employment Commission until 1940, when he became the principal analyst for the US Bureau of the Budget. He worked in public administration and the Office of War Information during World War II and published several studies for the American Society of Public Administration in the 1940s. McGee was the first director of the Texas State Legislative Budget Board in 1950. (Courtesy of Sherry Smith.)

TUDOR REDUX. Sherry and Tommy Jacks purchased the house at 2512 Wooldridge Drive in 1976 and remodeled it into a Tudor Revival–style house in 1983, as shown here. They imported the remodeled family room from a Scottish manor house and planted an English-style country garden. (Courtesy of Sherry Smith.)

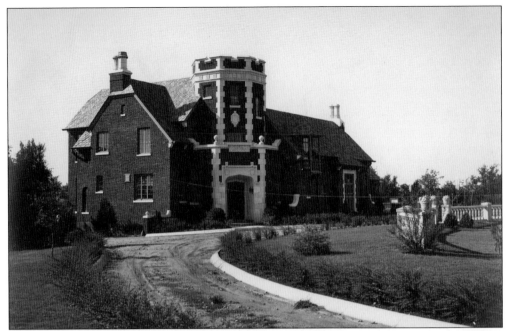

HILDEBRAND-SCOTT HOUSE. This distinctive home at 2431 Wooldridge Drive was designed in 1927 by the San Antonio firm of Adams and Adams, who also designed the ranch house for the King Ranch, the Kerr County Courthouse, and the 1933 Art Deco Texas State Highway Building at 125 East Eleventh Street. The Hildebrand-Scott house was built for Ira and Mabel Hildebrand. (Historic Landmark.) (Courtesy of AHC/APL, C01507.)

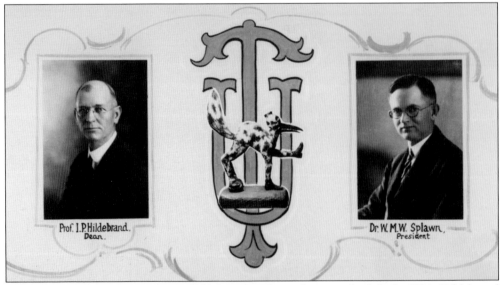

PROF. IRA HILDEBRAND. Professor Hildebrand is shown here on the left. In 1924, Hildebrand became dean of the University of Texas School of Law, a position he held until 1940. Dean Hildebrand earned law degrees from both the University of Texas and Harvard University. Under his leadership, the University of Texas law school grew to be one of the largest in the country. (Courtesy of Special Collections Department, Tarlton Law Library, University of Texas School of Law.)

2502 Wooldridge Drive. Architect Walter C. Moore Jr. designed the duplex at 2502/2504 Wooldridge Drive that became his parents' home in 1940. He also designed Hut's Hamburgers on Sixth Street and the historic Max Starcke House (see page 72). His father, Walter C. Moore, was a road contractor until about 1926, when he started the first sand and gravel plant in Austin. France Tips lived in the duplex from 1953 to 1966. She was the daughter-in-law of Walter Tips, founder of Tips Hardware Company (see pages 125 and 126). The Moore family owned the duplex until 1967. The home was converted to a single-family residence in the late 1980s. (Courtesy of William H. Prather.)

The Huron Mills House. Huron and Billie Mills built this Colonial Revival house at 2603 Wooldridge Drive in 1939. The photograph shows the home in 1940. Mills had opened the Cash Lumber Company at 3004 Guadalupe Street in 1928. It was the first lumber company in Austin operating on a strictly cash basis. The company's advertisement read, "You Pay Cash For Your Groceries, Why Not Your Lumber Too?" (Historic Landmark.) (Courtesy of Sabrina T. Brown.)

2505 WOOLDRIDGE DRIVE. This Colonial Revival–style home was constructed in 1940 for J. Rector Allen and his wife, Arch. The Allens lived here during the 1940s and 1950s while Rector was employed by E.M. Scarbrough & Sons department store. After serving as comptroller and supervisor in the 1940s, Allen was promoted to vice president. Scarbrough's remained in business until 2010. (Photograph by Suzanne Deaderick.)

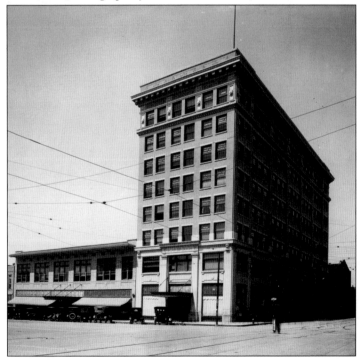

SCARBROUGH BUILDING. Scarbrough's department store opened in 1893 on Congress Avenue. The store was a success and moved to this Art Deco building, still in existence at Sixth Street and Congress Avenue in downtown Austin, about 1911. The store is shown here in the early 1930s. Scarbrough's was always the largest department store downtown, emphasizing fashionable apparel and home furnishings. It was the first Austin department store to use price tags and eliminate haggling. (Courtesy of AHC/APL, C00563.)

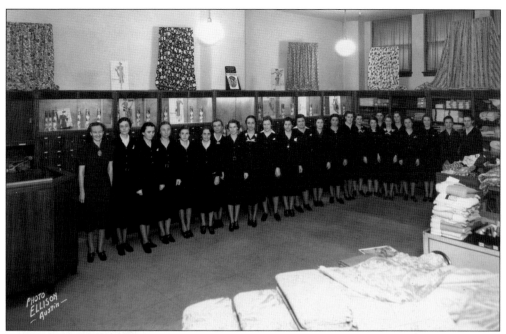

SCARBROUGH'S FABRIC DEPARTMENT. Clerks stand ready to help customers with fabric and notions in this January 18, 1938, photograph. Scarbrough's department store decided that rather than deal with wholesalers, it would bring the latest fashions directly from New York City to Austin. (Courtesy of AHC/APL, C05521.)

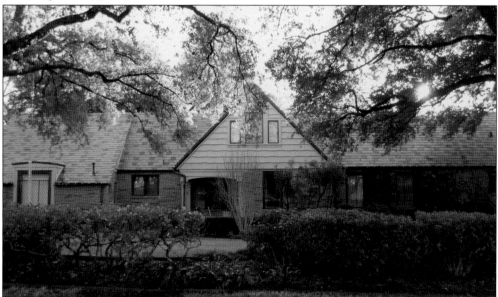

THE POTTER-PINCOFFS HOUSE. A combination of postwar Tudor Revival and Ranch, the 1948 house located at 2607 Wooldridge Drive was built for Ernest and Geneva Potter. The Potters owned the Hitchin' Post, a steak and seafood restaurant on North Lamar Boulevard, and Jene Dress Shop on Guadalupe Street. Mary and Edmund Pincoffs purchased the home in 1967. Dr. Edmund Pincoffs served as the chairman of the Department of Philosophy at the University of Texas. (Historic Landmark.) (Photograph by Suzanne Deaderick.)

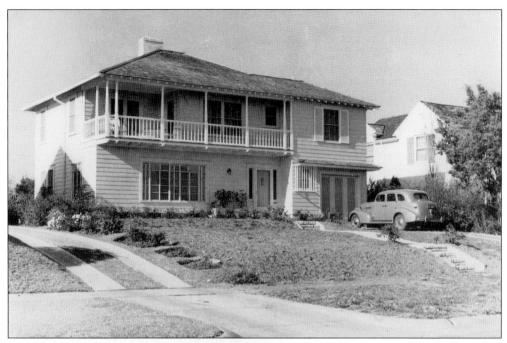

2516 Wooldridge Drive. Clarence and Beulah Lyon built this house in about 1941 to resemble their previous home in South Dakota, a gray, shingled house with casement windows, but Clarence regretfully had to give up his basement. Unfortunately, he died suddenly on a hot day in July while he was inspecting the home before its completion. His wife and children lived here until the mid-1950s. (Courtesy of Sally Medford.)

Prof. Clarence Lyon. A quiet and gentle man, Lyon was born in Iowa in 1884. He received his doctorate from Grinnell College in 1908 and became an instructor, and then professor of speech, at the University of South Dakota in 1911. In 1939, Lyon received an honorary degree from Yankton College for his teaching service to the youth of South Dakota, and he joined the University of Texas as an associate professor of speech that same year. (Courtesy of Sally Medford.)

Beulah Lyon. In 1910, Beulah Hanners married Clarence Lyon in Missouri. After her husband's death, Beulah became a speech clinician at the University of Texas. She and her husband both had enjoyed the theater, so it was natural that Beulah would author several plays and an "Oriental pantomime." One of her plays won second place in a contest sponsored by the National Federation of Women's Clubs. (Courtesy of Sally Medford.)

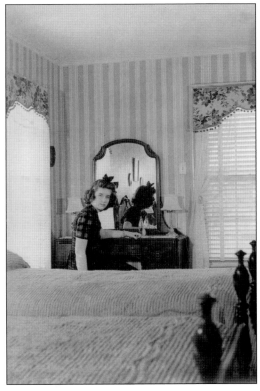

Elizabeth Lyon. Clarence and Beulah Lyon had four children. Elizabeth Ray Lyon, shown here, was their only daughter. When she was a girl, Elizabeth longed to look like Shirley Temple, who was then at the height of her popularity. This photograph allows a rare glimpse of the inside of a Pemberton Heights home in 1941. The wallpaper and window treatments were carefully selected by the Lyons for their new home. (Courtesy of Sally Medford.)

2601 WOOLDRIDGE DRIVE. This home was built in 1942 and was the residence of the John R. Reed Jr. family and later the Jon P. Newton family. Newton was an oil and gas attorney who served as a Texas railroad commissioner and chairman of the University of Texas Board of Regents in the 1970s and 1980s. The home was demolished in 2011. (Photograph by Suzanne Deaderick.)

AURELIA AND JACK REED. John R. "Jack" Reed Jr., a native Austinite, joined his father in the J.R. Reed Music Company, located on Congress Avenue. The company advertised itself as "Austin's leading music house since 1901" and employed about 70 persons at the time of Reed's death in 1961. This photograph shows Aurelia and Jack Reed (left) with Irma and Ernest Wilde. (Courtesy of AHC/APL, PICB11001.)

LIEUTENANT COMMANDER REED. Jack Reed was a veteran of World War II and is shown here in his Navy uniform in 1943. He was a quiet and kind man who preferred to remain in the background but whose thoughtfulness and generosity earned him many friends. He and his wife financially supported a number of University of Texas fine arts students and anonymously supplemented the salary of a faculty member. (Courtesy of AHC/APL, PICB11000.)

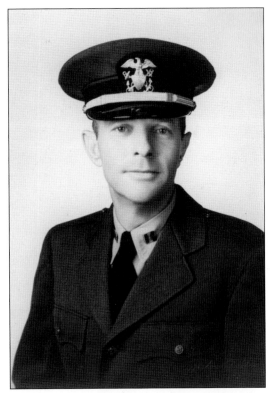

2610 WOOLDRIDGE DRIVE. This was once the home of Murdow K. and Zelta McAngus. It was built in the Spanish Colonial style on a double lot in 1936. The McAnguses, along with Murdow's brother William, owned McAngus Brothers Grocery, located at 607 Trinity Street in downtown Austin. The two-story limestone and brick grocery building still stands. (Courtesy of AHC/APL, PICH03994.)

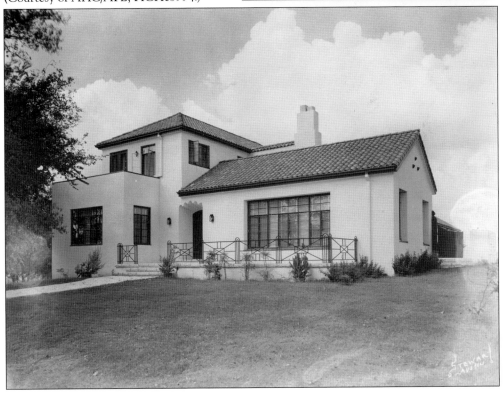

CLAUDE WILD. Prominent Austin attorney Claude C. Wild managed Lyndon B. Johnson's first campaign for the US Senate in 1941 (see page 63). Wild served in both world wars and commanded a prisoner of war camp in San Antonio during World War II. Claude and Leona Peters Wild lived at 2803 Wooldridge Drive. (Courtesy of AHC/APL, PICB09894.)

DARNALL HOUSE. Austin internist Dr. Charles M. Darnall and his wife, Queenie, had this house at 2805 Wooldridge Drive built in 1941. Dr. Darnall founded the Capital Medical Clinic in 1934. One of his friends and patients was architect Arthur Fehr, of Fehr & Granger, who had recently turned from the traditional architecture of his training to modernism. Fehr designed this home, which features many built-ins, sliding doors, casement windows, and then-new fluorescent lighting. (Photograph by Suzanne Deaderick.)

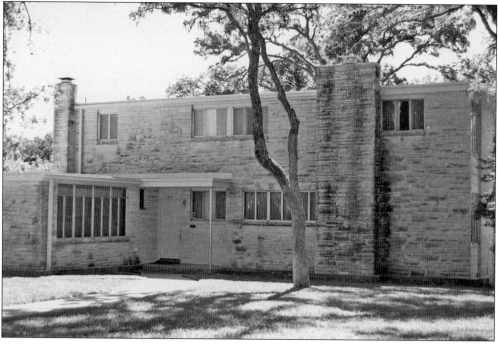

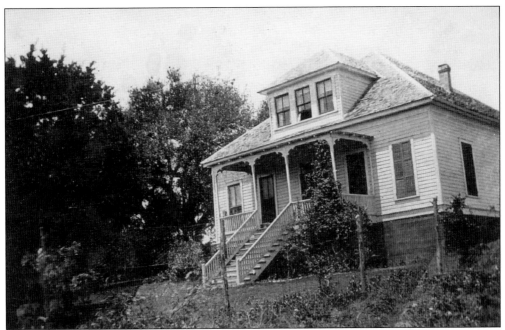

SPLITROCK HOUSE. The oldest surviving house in Pemberton Heights is shown here in 1915. It was built in 1892 by Scottish immigrant Thomas F. Burns. Burns arrived in Travis County in 1876. He worked on the railroads, became a stone mason, and then operated the Capitol City Marble Company in downtown Austin. The home has a traditional center-hall design with three rooms on each side and bedrooms upstairs. (Historic Landmark.) (Courtesy of the Tasch family.)

SPLITROCK HOUSE FROM A DISTANCE. Splitrock originally was built to face Shoal Creek. In about 1927, as Wooldridge Drive developed, Splitrock was given number 2815, and the front door was moved to the other side of the house to face the street. Before development, however, the land that would become Pemberton Heights and Bryker Woods looked like this. (Courtesy of the Tasch family.)

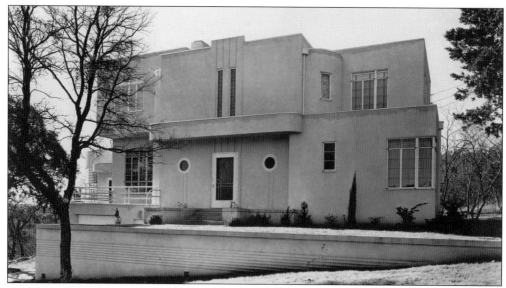

THE BOHN HOUSE. Located at 1301 West Twenty-ninth Street, just west of the Twenty-ninth Street Bridge, this house, shown in an undated photograph, was built for Herbert and Alice Bohn in 1938. It is considered Austin's finest example of the relatively rare residential Streamline Moderne architecture style. It was designed by Roy L. Thomas and built by Ernest Parker. The home's inspiration was the 1937 movie *Lost Horizon*. The dining room has an electric "moon gate" doorway that was copied from the movie. (Historic Landmark.) (Courtesy of AHC/APL, PICH07320.)

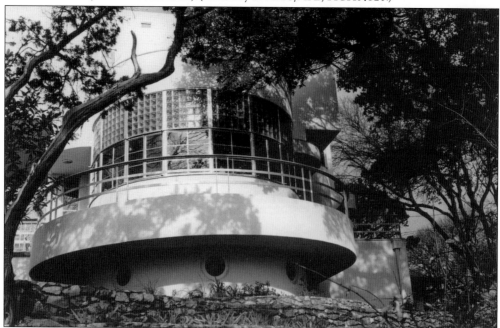

THE BOHN HOUSE, DETAIL. Streamline Moderne is held to be a late branch of the Art Deco style and reached its height of popularity in 1937. Moderne style is known for its curving forms, horizontal lines, glass block windows, and nautical detail, such as steel railings and porthole windows, all seen in this undated detail of the solarium at the east end of the house. (Courtesy of AHC/APL, PICH05450.)

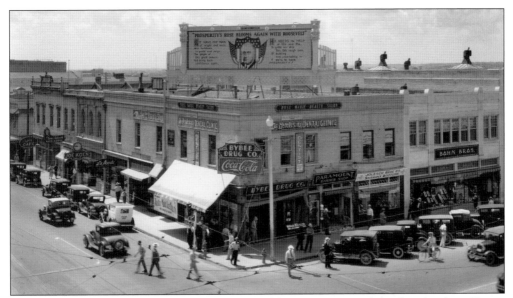

BOHN BROTHERS STORE. The Bohn family emigrated from Germany, and the three brothers, Henry, William, and Hermann, founded a department store on Congress Avenue in 1896. The "emporium" stocked such brands as Stetson hats, Griffon clothes, and Packard shoes. The storefront can be seen in the right of the photograph, which also features a sign promoting President Roosevelt's plans for economic prosperity. (Courtesy of AHC/APL, C00830.)

BOHN BROTHERS STORE INTERIOR. The Bohn Brothers store was one of the first in Austin to have a plate-glass display window, added in 1905, and later was one of the first to have air-conditioning, after the building was remodeled to two stories in 1929. Herbert Bohn eventually bought out his relatives' interest and changed the focus from a department store to a specialty fashion shop. He closed the business in 1960. (Courtesy of AHC/APL, PICA04796.)

THE IRELAND GRAVES FAMILY. This festive photograph shows, from left to right, Judge Ireland Graves; his granddaughter Molly Dougherty; his wife, Mary Stedman Graves; his son-in-law J. Chrys Dougherty III; his daughter Mary Ireland Graves Dougherty; and his grandson J. Chrys Dougherty IV. Judge and Mary Graves lived at 2 Green Lanes, while their daughter and her family lived at 6 Green Lanes. Judge Graves and J. Chrys Dougherty III were founding partners of what is now Graves Dougherty Hearon & Moody. (Courtesy of J. Chrys Dougherty III and Molly I. Dougherty.)

THE JUDGE GRAVES HOUSE. The house at 2 Green Lanes was designed in the Colonial Revival style by noted Austin architect Hugo Kuehne in 1936. The Colonial Revival style was popular between the world wars because of its simple and symmetrical lines and its patriotic associations. (Historic Landmark.) (Photograph by Susan Deadrick.)

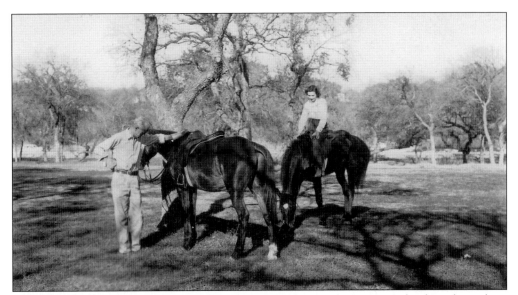

JUDGE GRAVES AND MARY IRELAND. Judge Graves and his daughter Mary Ireland are shown here in the late 1950s with their horses Jiggs and Midnight. In 1916, Graves became judge of the 26th District Court, which covered Austin and Georgetown. In 1922, he incorporated the Texas Law Review at the University of Texas law school, along with Dean Ira Hildebrand (see page 34) and Leon Green. In 1941, Graves argued a case before the US Supreme Court that established the Pullman Doctrine, strengthening state court powers. (Courtesy of J. Chrys Dougherty III and Molly I. Dougherty.)

6 GREEN LANES. J. Chrys Dougherty III and his wife, Mary Ireland, built a house at 6 Green Lanes in about 1951. The home is almost finished in this photograph. They had two children and remained close to her family. Chrys obtained a law degree from Harvard in 1940 and entered military service in 1941. He and his father-in-law, Judge Graves, formed a law firm in 1946. The home was demolished in 2011. (Courtesy of J. Chrys Dougherty III and Molly I. Dougherty.)

CHRYS AND MARY IRELAND GRAVES DOUGHERTY. Chrys Dougherty, now retired, specialized in estate, tax, and trust law. As president of the State Bar of Texas, he pioneered pro bono services for Texas with a commitment to ensuring equal access to justice. The Dougherty Arts Center in Austin is named in honor of Mary Ireland Graves Dougherty in recognition of her contribution to the arts and the cultural heritage of Austin. In this photograph, the couple has switched hats for fun. (Courtesy of J. Chrys Dougherty III and Molly I. Dougherty.)

MORGAN HOUSE. This rendering was done by architects Giesecke, Kuehne, and Brooks (see pages 20 and 117), showing the house to be built at 2401 Pemberton Place for Dr. Wellam Palmer Morgan and his wife, Frances Coopwood Morgan, in about 1950. Dr. Morgan was the first internist in Austin, and Frances was very active in civic and social organizations. The house is now owned by their daughter Frances Ramsey and her husband, George. (Courtesy of Frances and George Ramsey.)

Three

HARRIS BOULEVARD, McCALLUM DRIVE, AND WATHEN AND HARDOUIN AVENUES

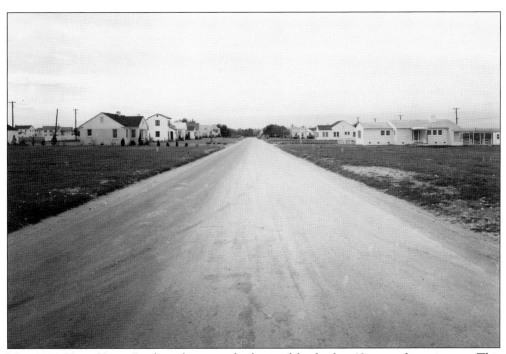

MAY 1938 VIEW. Harris Boulevard remained a dirt road for the first 10 years of its existence. This street scene is looking south from Preston Avenue shortly after Harris Boulevard was paved in 1938. Because the land, formerly Judge Harris's farm, had been covered in fields of corn and spinach, most of early Pemberton Heights was without trees. (Courtesy of AHC/APL, PICA17909.)

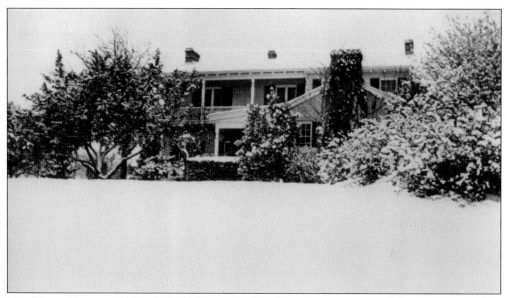

THE KEITH HOUSE, 1940s. At 2400 Harris Boulevard, with a view toward the Texas Capitol, is a house built for Maggie Mae Keith and her husband, Jacque N. Keith, in 1933. Maggie chose the house style after seeing a picture of a Monterey Revival home in a California building magazine. Monterey Revival combines elements of Spanish and Colonial architecture and features two stories, an L-shaped plan, and a cantilevered balcony. (Historic Landmark.) (Courtesy of AHC/APL, PICH09251.)

WILLIAM DIXON ANDERSON. Anderson purchased a lot in Pemberton Heights in 1927 and then sold it to his sister Maggie Mae Keith and her husband in 1933. Anderson studied architecture and later became chief builder for Calcasieu Lumber Company. He built the Keith House for his sister and probably constructed other homes in the area. Anderson, shown here in about 1960, was known for his stylish hats and boutonnières. (AHC/APL, PICB00125.)

THE BAKER-ALLEN HOUSE. Built by Paul B. and Lillie Baker in 1937, this house at 2402 Harris Boulevard is an excellent example of Colonial Revival architecture. Baker was a publisher's representative and book salesman. Later homeowner J.R. "Potsy" Allen Jr. was a founder of McCall, Hibler, and Allen Insurance Agency. Potsy's father served as public address announcer at home University of Texas football games for many years. (Historic Landmark.) (Photograph by Suzanne Deaderick.)

THE JACKSON-NOVY-KELLY-HOEY HOUSE. This Tudor Revival–style house at 2406 Harris Boulevard was built in 1930. Edna and Jim Novy, founder of the Austin Metal and Iron Company, were owners for 18 years. Automobile dealer Harry Kelly and his wife, Mary, owned it for almost 20 years before selling to Bill and Ann Knight Hoey. Bill was a successful artist, and Ann served as a priest at the Episcopal Church of the Good Shepherd in Tarrytown. (Historic Landmark.) (Photograph by Suzanne Deaderick.)

THE REED ESTATE, NORTH FACADE. Built in 1929 for Malcolm and Margaret Badger Reed, the Italian Renaissance villa at 2407 Harris Boulevard was designed by Henry "Hal" Bowers Thomson. The son of a prominent Austin ranching family, Thomson received his bachelor of science degree from the University of Texas and his master's degree in architecture from the Massachusetts Institute of Technology. The Reed Estate, whose entrance facade is shown here in 1932, is one of Austin's most ornate houses and exhibits all of the distinguishing features of an Italian Renaissance villa with its stone veneer, round arches, symmetrical composition, decorated brackets, cornices and eaves, casement windows, tiled roof, arcaded verandah, and decorative ironwork. (Historic Landmark.) (Courtesy of AHC/APL, C01538.)

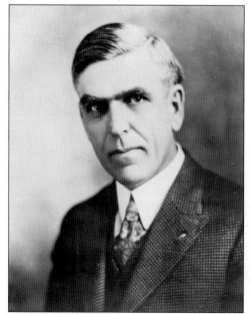

MALCOLM HIRAM REED. Born in Williamson County in 1876, Reed was in business for 15 years in Marble Falls, where he organized and was president of the Marble Falls State Bank. He moved to Austin in 1908 and became one of the leading cotton agents in Texas. M.H. Reed and Company was a major handler of cedar timber and pecans. Reed also negotiated the division and sale of more than 200,000 acres of land in the Texas Panhandle. (Courtesy of AHC/APL, PICB06896.)

PORCH WITH A VIEW. A rare style in Austin, Italian Renaissance houses are generally large with extensive and ornate decoration, appealing to the upper class in the 1920s with their opulence and grace. The cement, plaster, and lumber for the home came from Calcasieu (see pages 122 and 123), while the steel was fabricated by Tips Iron Works (see pages 125 and 126). It is not known whether the decorative metalwork was created by Tips, Fortunat Weigl, or another artisan. (Courtesy of AHC/APL, C01539.)

THE REED ESTATE, SOUTH FACADE. The home is two stories plus a basement. It has a concrete foundation and is made of masonry with a limestone veneer. The home is generally symmetrical, with a central structure featuring a porte cochère on the north. The south facade, shown here, features symmetrical curving stone staircases, a large patio, and recessed double doors of arched glass. The second-story windows have wooden shutters operated by cranks from within. (Courtesy of AHC/APL, PICH07862.)

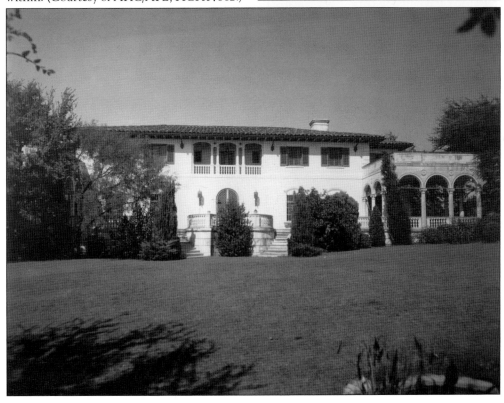

THE KNIPPA-HUFFMAN HOUSE. The house at 2414 Harris Boulevard may have been built as a spec home in 1928 by the Austin Development Company. This 1927 rendering predates the purchase of the property. A.C. Knippa and family were the first actual occupants. Knippa was a pioneer in the grocery business, modeling his Kash-Karry Grocery at Seventh Street and Congress Avenue after the national chains Piggly Wiggly and A&P, which had moved into the Austin area in 1918. (Historic Landmark.) (Courtesy of Margaret Best.)

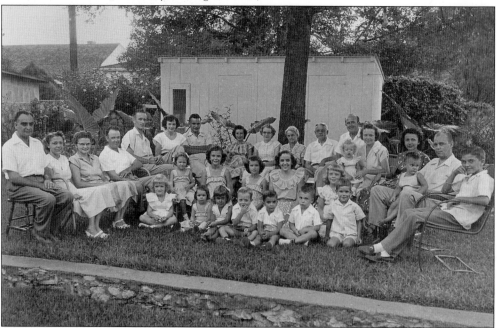

THE KNIPPA FAMILY. Margarethe Luker moved to Austin in 1908 and began working as a clerk at Bohn Brothers department store (see page 45), where she met A.C. Knippa. This photograph of the extended Knippa family was taken in the backyard of the home at 2414 Harris Boulevard on July 4, 1950. (Courtesy of Jan Slack.)

PETER MANSBENDEL DOOR. Swiss-born Peter Mansbendel (see page 120) is thought to have carved the front door of the Knippa house. The door was removed during a 1960s remodel and stored in the garage for 50 years. The current homeowners have restored the house to its original look with the carved door back in place. (Photograph by Suzanne Deaderick.)

MOUNT HUFFMAN, BIG BEND. Calvin Huffman was editor and publisher of the Eagle Pass newspaper before his election to the Texas House of Representatives in 1940. During his two terms, he was responsible for designating Big Bend National Park. This photograph shows Mount Huffman (far right) in Big Bend, named in his honor. Calvin and Olive Huffman lived at 2414 Harris Boulevard for over 50 years, from 1958 to 2009. (Photograph by David P. Cash.)

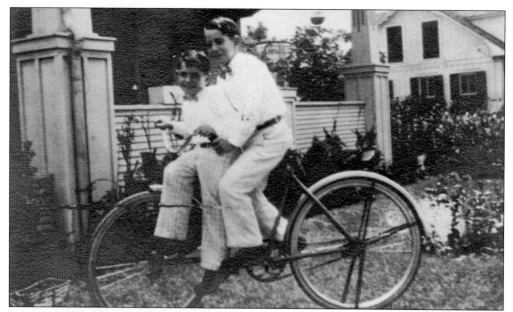

YORKTOWN BUDDIES TWO. The Goodfriend boys, who would later live at 2418 Harris Boulevard, were born in Yorktown, Texas. This 1925 photograph shows Nat and Irving on a bicycle in front of their home in Yorktown. Irving is the elder son. The youngest Goodfriend son, Melvyn, died at the age of 27 in a car accident. The Goodfriend family saw their store in Yorktown become the buying center of the DeWitt County area. (Courtesy of Sarah Goodfriend.)

THE GOODFRIEND HOUSE. While living on Palma Plaza in 1933, the Goodfriends purchased the lot at 2418 Harris Boulevard. Page Brothers was hired to design a beautiful Mediterranean-style home. Noted Swiss woodcarver Peter Mansbendel was commissioned to carve an intricate mantel for the fireplace in the living room. The Goodfriend family lived here for 46 years. (Historic Landmark.) (Photograph by Suzanne Deaderick.)

BENJAMIN GOODFRIEND. The Goodfriends set up their Austin business as a family-operated store. Benjamin and Augusta were on duty full time, and their three sons swept floors and delivered packages after school. The business thrived, and in 1946, they moved to a building at Ninth Street and Congress Avenue, enlarging it in 1951. Goodfriend's celebrated a half century of merchandising in Texas in 1964 with 33 of those years in Austin. (Courtesy of AHC/APL, PICB03154.)

GOODFRIEND'S AT 716 CONGRESS AVENUE. The striking modernistic storefront of Goodfriend's original Austin store is shown here in this March 30, 1941, photograph. The front featured a two-tone tan "California modern" color scheme, accenting recessed columns studded with bronze stars. Featured throughout the store was fluorescent lighting, which was a new development in the merchandising world. (Courtesy of AHC/APL, C05857a.)

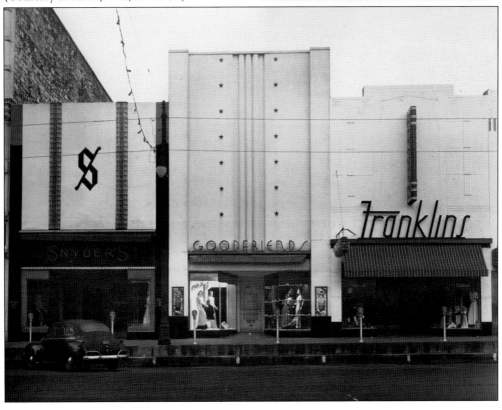

THE DUNBAR-EILERS HOUSE. In 1938, Marion Dunbar chose one of the few lots in Pemberton Heights that had existing trees. The grove of live oaks at 2502 Harris Boulevard was approximately 50 years old at that time. Marion purchased 30 additional feet of the adjacent lot to provide ample room to build her Ranch-style house behind these trees, which are now about 125 years old. (Historic Landmark.) (Photograph by Suzanne Deaderick.)

MARION BONE DUNBAR. A 1931 graduate of the University of Texas, where she also had been voted "Most Beautiful," Marion returned to Austin to teach Spanish at her alma mater. She hired noted Dallas builder Olin Scurlock to construct her new home at 2502 Harris Boulevard. Scurlock had built many of the houses in Dallas's Park Cities as well as part of Love Field and a University of Texas men's dormitory. (Courtesy of Keith Hollins.)

MARION DUNBAR IN MEXICO. Always interested in furthering her education, Marion traveled with her daughter Keith to study in Mexico City. Marion came from a very education-oriented family and was valedictorian of her Beaumont High School class. This picture was taken at the Floating Gardens of Xochimilco in Mexico City around 1942. Marion had two daughters, Keith and Meg, who now live in Tennessee. (Courtesy of Keith Hollins.)

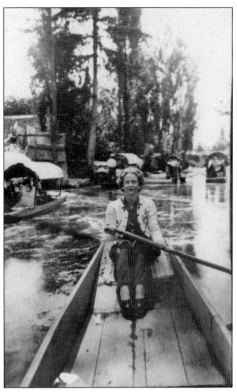

MCKEAN, EILERS & CO. ON CONGRESS AVENUE. This c. 1904 photograph shows M.M. Shipe, developer of Austin's Hyde Park neighborhood, crossing Congress Avenue in front of the McKean Eilers Building. McKean, Eilers & Co. sold wholesale dry goods and furnishings. The building still stands on Congress Avenue and is a City of Austin historic landmark. The Eilers owned the house at 2502 Harris Boulevard for 34 years. (Courtesy of AHC/APL, C00282.)

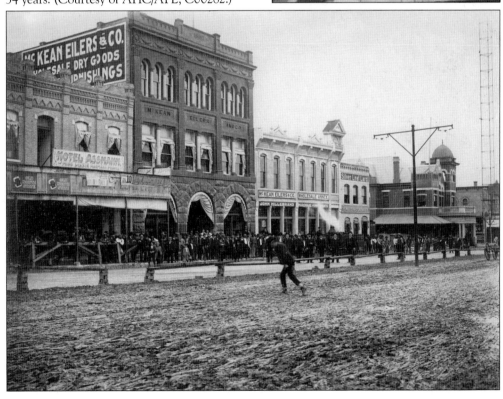

THE SILBERSTEIN HOUSE. This Tudor Revival–style house at 2506 Harris Boulevard was built in 1940 for Max and Sadye Silberstein. Max Silberstein opened his first retail store with his brother Sam at 309 East Sixth Street, selling only shoes and hats. The Silbersteins raised their twin sons in this house and resided here for 28 years. (Historic Landmark.) (Courtesy of Nita Silberstein.)

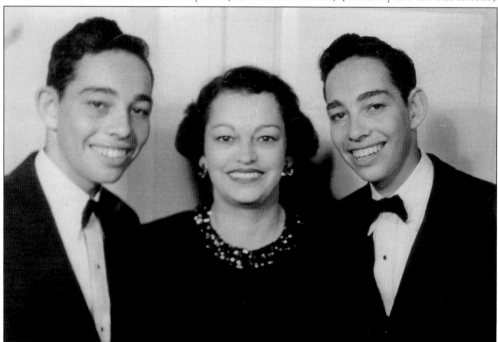

SADYE, HORACE, AND JONAS SILBERSTEIN. In the early 1950s, Max and Sadye helped their twin sons open a retail shop at Twenty-third and Guadalupe Streets called Jorace Men's Wear. They arrived at this name by combining the names of their two sons, Jonas and Horace. This was a common practice among Jewish merchants at that time. (Courtesy of Nita Silberstein.)

MAX SILBERSTEIN AND CUSTOMER.
After the war, Max went into business
with Sol Ginsburg (see page 105) to
open the Austin Man's Shop, which
became known as the place to go for
quality working men's clothing. Max is
shown here with a customer in his store
on Sixth Street. Although Austin had
a synagogue as early as 1875, many of
the Jewish merchant families chose to
meet in one of the Sixth Street stores to
worship. (Courtesy of Nita Silberstein.)

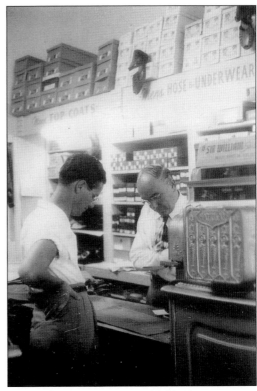

STROBLE HOUSE. Located at the corner of
Harris Boulevard and Ethridge Avenue,
this house was owned by Mr. and Mrs.
J.L. Stroble. The Strobles were the
proprietors of Stroble's Café, located
at 111 West Seventh Street, right off
Congress Avenue. The historic appearance
of this house has been maintained.
(Courtesy of AHC/APL, C01484.)

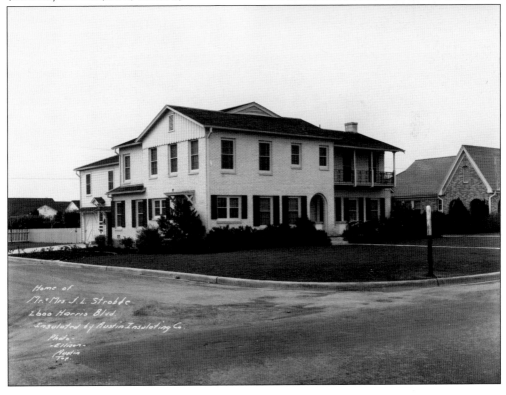

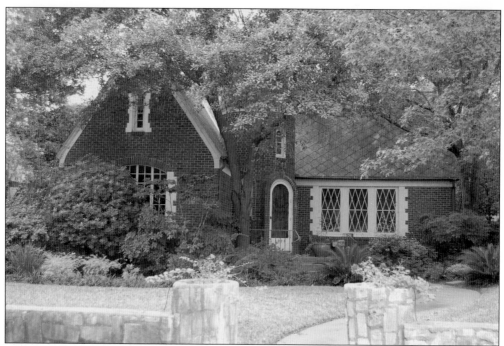

THE SNYDER HOUSE. Louis Snyder had most of his money tied up in his new store, Snyder's Smart Shop. Unbeknownst to Louis, his wife, Rae, was saving a little of her household allowance each week. One afternoon in 1936, Rae took Louis for a drive and turned onto unpaved Harris Boulevard to show him the lot she had saved up to buy. Rae designed her house at 2508 Harris Boulevard to resemble a French chateau. (Historic Landmark.) (Photograph by Suzanne Deaderick.)

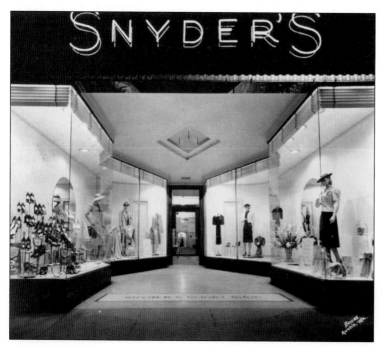

SNYDER'S SMART SHOP ON CONGRESS AVENUE. Louis Snyder opened his women's clothing store in 1933. The business thrived, and in 1950, Louis's two sons joined him. The store was renamed Snyder-Chenards, "Chenards" being a combination of his sons' names (Chester and Bernard). The store was a mainstay for Austin shoppers until it closed around 1982. (Courtesy of AHC/APL, PICA28595.)

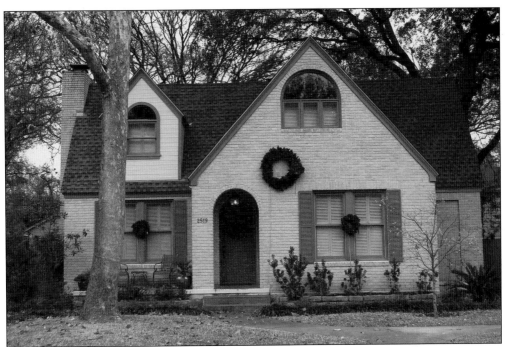

REBEKAH JOHNSON'S HOUSE. Rebekah Johnson lived in this 1935 house at 2519 Harris Boulevard from 1942 until her death in 1958. While she lived here, her son Lyndon Baines Johnson was first a member of the US House of Representative and then the US Senate. She did not, however, live to see him succeed to the presidency in 1963. Her family later remodeled Rebekah's house. (Photograph by Suzanne Deaderick.)

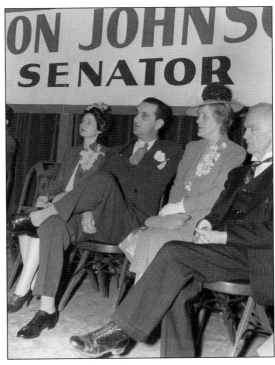

REBEKAH BAINES JOHNSON. Rebekah Johnson moved to Austin from the Texas Hill Country after her husband's death in 1937. This 1941 photograph shows, from left to right, Lady Bird Johnson, Lyndon Baines Johnson, Rebekah Baines Johnson, and possibly campaign manager Claude Wild (who lived on Wooldridge Drive, see page 42) on May 3, 1941, at a rally opening LBJ's 1941 US Senate campaign. (Courtesy of LBJ Library.)

THE CATTERALL-MILLS HOUSE. The house at 2424 Harris Boulevard was built in 1937 for Gordon and Margaret Catterall Mills in the Early American Georgian Revival style, modeled after George Washington's Mount Vernon estate. Gordon Mills was vice president and assistant general manager of Walker's Austex Chili Company, which Margaret's father owned. Because Bergstrom Air Force Base near Austin was felt to be a prime target for Russian attack, the house had a bomb shelter built in the backyard. (Historic Landmark.) (Photograph by Suzanne Deaderick.)

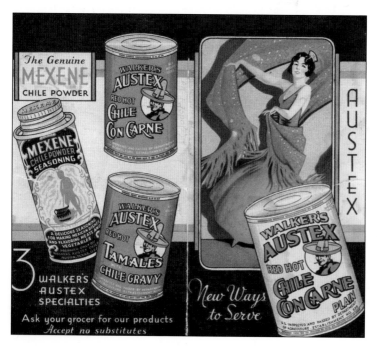

WALKER'S MEXICAN SPECIALTIES. In the 1930s, there were three major employers in Austin: the University of Texas, the state government, and Austex Chili Company. During World War II, Austex Chili secretly converted its canning company into one of two US facilities that provided all of the military rations to the Allied troops, helping to popularize Mexican-style food. Peppers for the chili were grown south of town. (Courtesy of AHC/APL, AF-F2500[1]-001.)

64

THE LEACH HOUSE. When World War II began, Germany was well positioned to use magnesium for aircraft construction. In response, American companies stepped up their magnesium manufacturing efforts. In 1941, the Lower Colorado River Authority joined forces with Austin to acquire a wartime industry. William Leach was brought from New York to design and oversee the building of a new magnesium plant, which employed more than 600 people. Leach was manager of the plant until 1946. It later became the Balcones Research Center and is now the J.J. Pickle Research Campus. William and Helen Leach lived at 1402 Wathen Avenue. (Historic Landmark.) (Photograph by Suzanne Deaderick.)

THE PACE-PERRY HOUSE. This Colonial Revival–style house at 1403 Wathen Avenue was built in 1937 for Jarrett and Beulah Pace, who lived there for 30 years. Jarrett worked for Allyn & Bacon publishing company and later Macmillan Publishing Company, and Beulah championed physical education for disabled children at the Texas Department of Mental Health and Mental Retardation. The Reverend Hal Perry and his wife, Mary Ann, lived here for eight years. Perry was prominent at the Episcopal Seminary of the Southwest, and an award is given annually in his honor. (Historic Landmark.) (Courtesy of J.B. Pace.)

THE AYCOCK HOUSE. Designed by Hugo Kuehne, this 1938 brick cottage is located at 1405 Wathen Avenue. John and Dorothy Aycock lived in the house until their divorce around 1960. Dorothy continued to live there for the next 22 years. She was the proprietor of Dorothy's Gift Box on Thirty-fourth Street. (Historic Landmark.) (Photograph by Suzanne Deaderick.)

JOHN C. AYCOCK. John Aycock was an assistant city attorney for Austin, an assistant state attorney general, and later president of City National Bank. He opened the Austin office of E.F. Hutton in 1963. John was very active in many civic and philanthropic activities in Austin, especially the Boy Scouts. (Courtesy of AHC/APL, PICB00228.)

THE REILLY HOUSE. In 1937, Margaret Reilly hired Ernest Parker to build "a frame residence and box garage" at 1406 Wathen Avenue. Margaret taught school for 51 years and was named outstanding female teacher in Texas. Margaret's nephew J. Aubrey Reilly and his wife, Florence, later moved into the house and lived there until 1970. Laurens and Julia Fish, proprietors of Austin's most prominent funeral home business, owned the house for the next 25 years. (Historic Landmark.) (Photograph by Suzanne Deaderick.)

MARGARET REILLY. Margaret Reilly was a prominent schoolteacher and principal of several schools in Austin. She began teaching in Austin in 1888 and was named principal of the John B. Winn School in 1906. Margaret taught at Austin High School and Bickler Elementary, and served as principal of Bickler and Ridgetop Schools. The Margaret Reilly Elementary School on Denson Drive was named in her honor in 1954. (Courtesy of AHC/APL, PICB07571.)

WALTER MCNEIL HOUSE. The two-story frame house at 1407 Wathen Avenue was built for $4,000. Huron Mills, who owned the Cash Lumber Company, lived in this house prior to building his house at 2603 Wooldridge Drive (see page 35). Walter McNeil, who was a professor at the University of Texas, lived here with his wife, Winifred, in the 1940s. (Courtesy of AHC/APL, PICH02888.)

AULER HOUSE, 1408 WATHEN AVENUE. Dr. Hugo Auler was a prominent physician in Austin for 20 years. Hugo and his wife, Mary Blanton Auler, had one son and one daughter. Son Ed and his wife, Susan, are the owners of Fall Creek Vineyards. Daughter Mary Ann married Dr. Greenwood S. Wooten Jr., whose father owned and operated the Greenwood Drug Company (see page 27). (Courtesy of AHC/APL, C01480.)

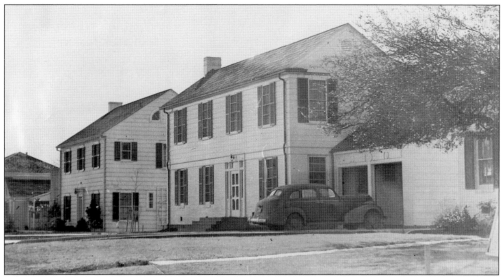

The Hardwicke House. Located at 1409 Wathen Avenue, this two-story house was built for Dr. Charles and Maurine Hardwicke in 1938. Dr. Hardwicke was a proctologist, and his wife, Maurine Rutland Hardwicke, started the Cupboard at St. David's Hospital. Maurine's mother, Willie Rutland, lived with them for several years and was a curator at the Elizabet Ney Museum. Maurine lived in the house from 1938 until her death in 2007. (Historic Landmark.) (Courtesy of Ann Moody.)

The Gambrell House. Dr. William Gambrell was one of the best-known physicians in Texas during the 1950s. Roy Thomas designed the Gambrell home at 1410 Wathen Avenue, and Ernest Parker built it. Dr. Gambrell was instrumental in securing the movement of the Texas Medical Association (TMA) headquarters to Austin. He served as president of the TMA at the same time that his wife, Patti, served as president of the Women's Auxiliary of the TMA. (Historic Landmark.) (Photograph by Suzanne Deaderick.)

THE WILDER HOUSE. Built in 1950 for Harry Wilder Jr. and his wife, Alice Ann Nitschke Wilder, this French Provincial house at 1412 Wathen Avenue was designed by noted architect Armon Mabry. Mabry was a professor in the architectural engineering department at the University of Texas. He specialized in French designs; this is the only known Mabry design in Austin. The house remains in the Wilder family. (Historic Landmark.) (Courtesy of Diane Howard.)

HARRY STANLEY WILDER JR. After graduating from the University of Texas as a petroleum engineer, Harry went to work for Dow Chemical during World War II. He was a building contractor through the 1960s while also operating an insurance agency. Harry owned Wilder's Gem and Mineral Shop and was known for taking interesting rocks and minerals to area schools to help children understand and appreciate geology. (Courtesy of Diane Howard.)

ALICE ANN NITSCHKE WILDER. Alice Ann and her husband, Harry, along with her parents, Hillaire and Winnie Ramsey Nitschke, developed the Rosedale subdivision and a shopping center that is now Rosedale Village on Burnet Road. Alice Ann's daughter Diane Wilder Howard has been instrumental in the urban redevelopment and revitalization of the Rosedale commercial area in the last few years. (Courtesy of Diane Howard.)

THE WILDER CHILDREN. Hillaire (age 16) and Diane (age 14) Wilder sit on the front steps of their new French Provincial home at 1412 Wathen Avenue. Dr. Hillaire Wilder is an educator, artist, and social activist. Diane Wilder Howard was a Universal Press food and travel columnist before retiring her column to pursue her interest in urban redevelopment. (Courtesy of Diane Howard.)

The Max Starcke House. Located at 1400 Hardouin Avenue, this house originally was designed by Walter C. Moore Jr. for his father, who was retiring from owning the first screening sand and gravel plant in Austin. The home was a duplex, which was a unique plan for Pemberton Heights at the time. It was built in 1938 in the Streamline Moderne style by Ernest Parker. Max Starcke rented one side of the duplex when he moved to Austin to become the first operations manager for the Lower Colorado River Authority (LCRA). (Historic Landmark.) (Photograph by Suzanne Deaderick.)

Max Starcke with Company. Starcke guided the LCRA through its development of the Highland Lakes chain on the Colorado River above Austin. The electrical power generated by the dams and hydroelectric power plants expanded the authority's service area to 41,000 square miles. In 1940, Starcke was promoted to general manager, and he remained in that position until he retired in 1955. The Max Starcke Dam in Marble Falls, Texas, was named for him. (Courtesy of AHC/APL, AR.S.003[054].)

LYNDON JOHNSON AND MAX STARCKE.
While Starcke was still at the LCRA, he helped found the Texas Water Conservation Association and served as its vice president for 13 years and president for five years. He was one of the nation's outstanding authorities on water conservation and served on the natural resources advisory committee during the Kennedy-Johnson campaign. In this photograph, Starcke is in the middle, with Lyndon Johnson standing at the microphone. (Courtesy of AHC/APL, AR.S.003[056].)

THE BOOTERY. Matt Spires came to Austin around 1921 and began his retail career as the manager of the White Shoe House on Sixth Street. Within six years, he was president and owner of the French Boot Shop at 720 Congress Avenue. Ten years later, Spires had expanded to own The Bootery, shown on the far right in this undated photograph, at 606 Congress Avenue. (Courtesy of AHC/APL, C0049.)

THE SPIRES-SEEKATZ HOUSE. When Pemberton Heights was developing in the late 1920s and 1930s, it was rare to see a contemporary-style house. But the house that Matt and Ida Mae Spires built at 1406 Hardouin Avenue in 1937 featured a curved corner by the front door, horizontal bands around the house, and brick panels above the front door, all suggesting Art Moderne influence. (Historic Landmark.) (Photograph by Suzanne Deaderick.)

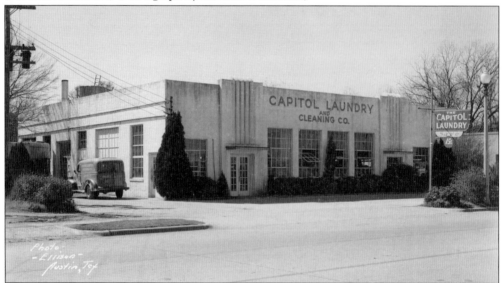

CAPITOL LAUNDRY. Originally known as Capitol Linen Supply Company, the business was started by Roy Seekatz in 1937. It was located first at 801 Barton Springs Road, which later became the Filling Station Restaurant (now demolished). The business was renamed Capitol Laundry and Cleaning Company and eventually grew to four locations. Seekatz owned and operated the laundry for 36 years and lived at 1406 Hardouin Avenue. (Courtesy of AHC/APL, C06162.)

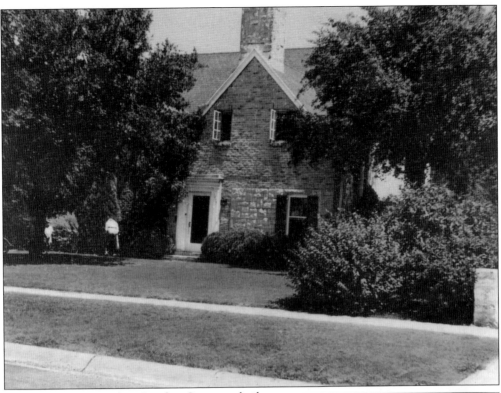

WARREN HOUSE. Brydson Lumber Company built this house at 1502 Hardouin Avenue in about 1930 for William and Eleanor Warren, who remodeled it just 10 years later and eventually lived there for over 50 years. The Warrens owned Brydson Lumber Company, which was located at Nineteenth and Guadalupe Streets. Brydson's ad read, "A good substantial house is a splendid monument to a man's usefulness." (Courtesy of AHC/APL, PICH08174.)

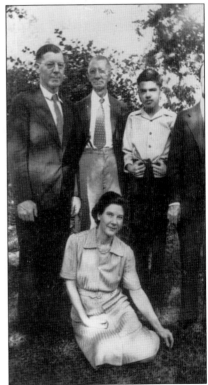

WILLIAM FREDERICK WARREN AND FAMILY. Pictured most likely in the yard at 1502 Hardouin Avenue are, from left to right, William Frederick Warren; his father, William David Warren; and William Frederick's son David Warren. Sitting on the grass in front is Marjorie Warren. William Frederick Warren died in 1984 at the age of 89. (Courtesy of AHC/APL, PICB19357.)

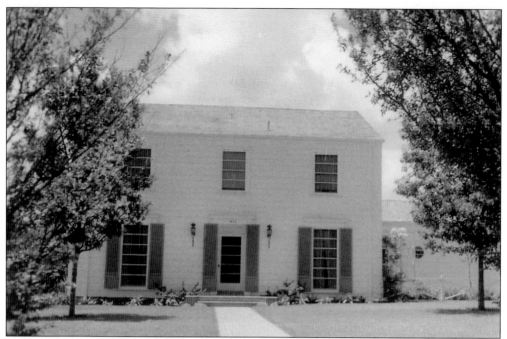

THE CATTERALL-THORNBERRY HOUSE. Fred W. Catterall Jr. and his wife, Electra, built the American Colonial Revival–style house at 1403 Hardouin Avenue in 1938 and lived there for 26 years. Fred was president of Walker's Austex Chili Company (see page 64) for many years and later was a director of Frito-Lay Corporation in Dallas. (Historic Landmark.) (Courtesy of D. Van Sickle.)

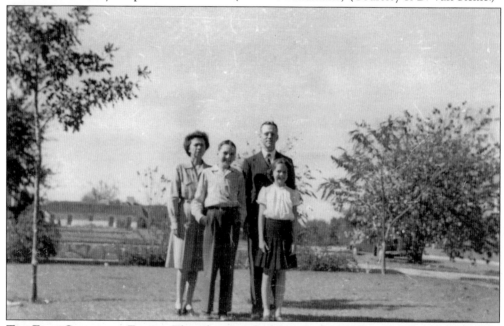

THE FRED CATTERALL FAMILY. This photograph shows Fred and Electra Catterall with their children, Fred and Jean, outside their house on Hardouin Avenue. Fred was president of the Austin Rotary Club, president of the chamber of commerce, president of the United Fund, and president of the Austin Symphony Society. (Courtesy of D. Van Sickle.)

JEAN AND FRED CATTERALL. Young Jean and her brother, Fred, are shown in this 1942 photograph on the back porch of their house at 1403 Hardouin Avenue. Their mother, Electra, earned a chemistry degree at the University of Texas. Electra's father was the Texas state health officer, appointed by Gov. Dan Moody. (Courtesy of D. Van Sickle.)

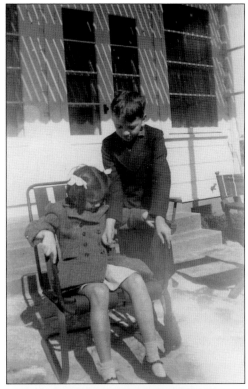

ELOISE AND HOMER THORNBERRY. The Thornberrys were the second owners of the house at 1403 Hardouin Avenue, living there from 1964 to 1978. Homer was a member of the Texas House of Representatives and in 1948 was elected a US congressman, taking Lyndon B. Johnson's place when he successfully ran for the US Senate. Thornberry later became a federal judge on the Fifth Circuit Court of Appeals. The federal court building in New Orleans is named for him. (Courtesy of D. Van Sickle.)

THE BRYAN SPIRES HOUSE. The house at 1500 Hardouin Avenue was built in 1935 for A. Bryan Spires. It was designed by C.H. Page & Son, architects (see page 119), and is the firm's only known example of American Colonial Revival. The house had features innovative for its time, such as a dressing room bath suite, walk-in closets, and creative built-ins. (Historic Landmark.) (Photograph by Suzanne Deaderick.)

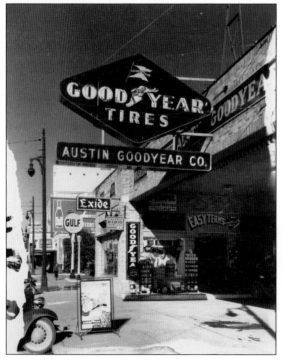

AUSTIN GOODYEAR COMPANY. Bryan Spires owned and operated the Austin Goodyear Company from 1927 to 1947. Austin Goodyear began in 1855 as a livery and sales stable located across the street from the downtown Driskill Hotel. In 1931, as automobiles were becoming common in Austin, the company moved into a building designed for auto service. (Courtesy of AHC/APL, C00356.)

Bryan Spires and Business. Austin Goodyear Company was one of the first businesses to be open 24 hours a day and continued to grow throughout the Depression and World War II. Spires's company supplied tires and batteries to the US military during the war. After selling his company in 1947, Spires became vice president and director of Austin National Bank. (Courtesy of AHC/APL, C00353.)

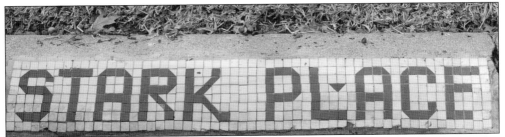

Tiled Street Sign. Stark Place intersects Hardouin Avenue near the Bryan Spires house. This photograph shows one of the tiled street signs that were integrated into the curbs of the first streets to be developed in Pemberton Heights. Stark Place may have been named for H.J. Lutcher Stark, a prosperous businessman whose career began with an East Texas lumber empire. In 1919, Gov. W.P. Hobby appointed Stark, a University of Texas graduate who popularized the longhorn as the school's mascot, to the University of Texas Board of Regents. Stark owned land in Pemberton Heights. (Photograph by Suzanne Deaderick.)

CHARLES AND MARIAN BONER HOUSE. In 1936, Charles and Marian Boner built a Tudor Revival house, designed by noted Austin architect Roy Thomas, at 1508 Hardouin Avenue. Dr. Boner was renowned as a church organist, and a 1941 article in the *Dallas Morning News* stated that Dr. Boner had plans to build an organ in the attic of his new house. However, the house was built without it. (Courtesy AHC/APL, AR.2009.036[001].)

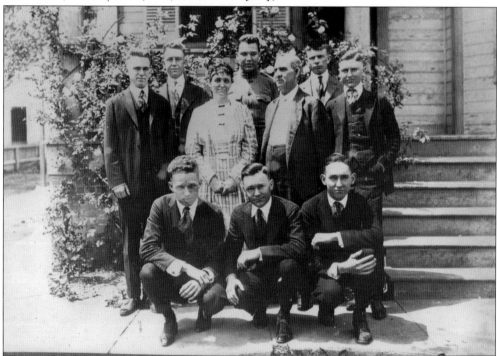

"THE BONAR BUNCH." This picture of the Bonar (sic) Bunch shows Dr. Charles Paul Boner kneeling on the right. His father, Charles Wilbur Boner, is the older gentleman in the middle, and the woman is Sally Elizabeth Boner, Dr. Boner's mother. Dr. Boner founded the University of Texas's former Defense Research Laboratory, which later became Applied Research Laboratories. He served as its director for 20 years. (Courtesy of AHC/APL, PICB12201.)

MARIAN OLDFATHER BONER. When the Boners' sons entered grade school, Marian enrolled in the University of Texas law school, where she distinguished herself as a student and published author, graduating second in her class. The university hired its talented graduate, and Marian became an associate professor of law and reference librarian. In 1972, she became librarian at the State Law Library. In this photograph, she is second from the right. (Courtesy of AHC/APL, PICB00830.)

DR. CHARLES PAUL BONER. Dr. Boner was an internationally known physicist in the field of acoustics. His extensive knowledge put him in demand as a consultant in the design of radio studios and auditoriums nationwide. During World War II, Dr. Boner left the University of Texas to become associate director of the Underwater Sound Laboratory at Harvard University. He became a leading expert on underwater sound defense. (Courtesy of AHC/APL, PICB00829.)

STREETSCAPE, 1940. Taken in January 1940, this photograph shows McCallum Drive looking north from the corner of Wathen Avenue. Note the metal trash cans on the far right in the picture. While this street scene shows there to be quite a few houses, much of Pemberton Heights was still vacant lots. (Courtesy of AHC/APL, PICA18081.)

ARTHUR MCCALLUM. McCallum lived from 1865 to 1943, moving to Texas in 1895. In 1903, he was elected superintendent of the Austin public schools, a position he held for 39 years. During his tenure, the school system grew from 4,459 to 16,128 students. He believed in education for all races of children and hired the district's first Hispanic teacher in the 1920s. McCallum Drive is named for him and his wife. (Courtesy of AHC/APL, AR.E.04[119].)

JANE MCCALLUM. Jane McCallum lived from 1877 to 1957. In this photograph, she is on the far right. She married Arthur McCallum in 1896. She was a suffragist leader and state chairwoman of the ratification committee for the 19th Amendment to the US Constitution. In 1927, Gov. Dan Moody appointed her Texas secretary of state. While she was serving in that office, she discovered an original copy of the Texas Declaration of Independence in a vault at the state capitol. McCallum Drive is named for her and her husband. (Courtesy of AHC/APL, AR.E.05[105].)

IKINS-MESSER HOUSE. This home was built in 1938 by Dr. Clyde Ikins and his bride, Bernice Wilder. Milton and Bonnie Messer moved into the home in 1950, despite Milton's father's comment that it was "a nice house but too far away from everything." The Messers lived here until about 2004. The house was demolished shortly after it was sold. (Courtesy of AHC/APL, PICH04031. Photograph by Bill Malone [1924–2000] of Bill Malone Photography, Austin, Texas. Used with permission.)

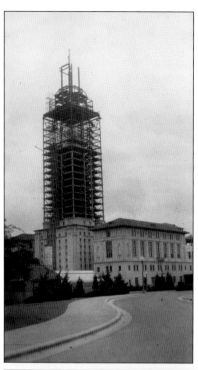

TOWER UNDER CONSTRUCTION. Milton Messer was a fifth-generation blacksmith and machinist. His father founded Modern Supply Company in Austin in 1933. Messer took over the company in 1942. One of the company's projects was the framework for the 1934 University of Texas Tower, shown here. Another project was the six plaques showing the six flags over Texas on the east face of the State Archives Building. Messer liked to say his company could weld anything from the crack of dawn to a broken heart. (Courtesy of AHC/APL, PICA07820.)

CLYDE IKINS AND MOSASAUR. Dr. Ikins studied science at the University of Texas. In 1934, he and another student discovered a rare full skeleton of a 30-foot mosasaur, shown here. Ikins's interest in botany led to a 15-by-20-foot lily pond in the front yard of the house on McCallum Drive, and he later amassed one of the most complete water lily collections in the world. (Courtesy of Texas Natural Science Center, the University of Texas at Austin.)

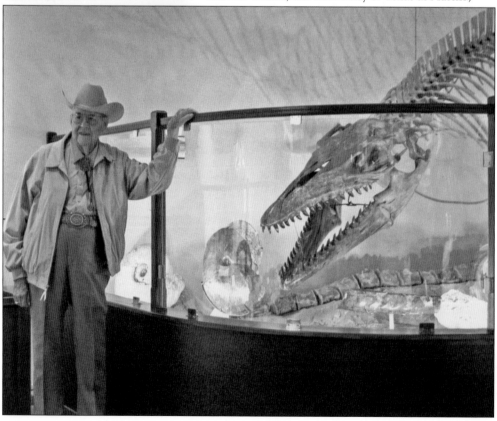

Four

GASTON, JARRATT, CLAIRE, AND ETHRIDGE AVENUES

STREET SCENE ON GASTON AVENUE. Dated January 1940, this photograph looks east along unpaved Gaston Avenue toward McCallum Drive. The house on the right with a woman and child in the driveway was the home of architect Roy Thomas, who designed many of the homes in Pemberton Heights. The two-story house on the left (at the corner of Gaston Avenue and McCallum Drive) was the Ikins-Messer House, which was demolished in 2004. (Courtesy of AHC/APL, PICA17974.)

GASTON AVENUE, 1936. This photograph was taken on January 31, 1936, where Claire Avenue intersects Gaston Avenue. The photographer is looking roughly west up Gaston Avenue. This portion of Gaston Avenue is in the Shoal Terrace subdivision, which was platted by W.T. Caswell in the early 1930s. The photograph was taken to show the new street paving. (Courtesy of AHC/APL, PICA17973.)

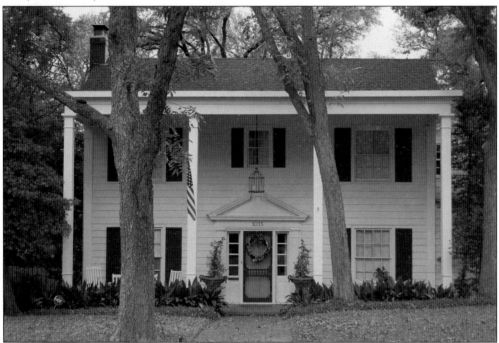

WARNER STEWART HOUSE. After returning from war service in 1946, Warner Stewart became executive director of the Austin Housing Authority (AHA), a position he held until his death in 1961. Under his leadership, the AHA provided more than 800 housing units for low-income families and the aged. Mary and Warner Stewart owned the house at 1015 Gaston Avenue for 24 years. It was built in 1936. (Photograph by Suzanne Deaderick.)

SCHULZ-BEHREND HOUSE. Architect Roy Thomas designed this house at 1100 Gaston Avenue, which is pictured here in 1940. Sol and Ester Norman owned the home before selling it to George and Betty Schulz-Behrend. In 1946, George began a more than 40-year career as a professor of Germanic languages at the University of Texas. He died in 2010 as professor emeritus at the age of 97; after his death, the home was rebuilt to look substantially similar. (Courtesy of AHC/APL, PICH07315.)

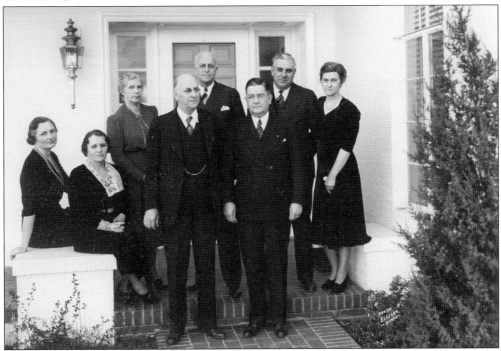

THE NASH FAMILY. John H. Nash Sr. and his wife, Lucille, are shown here with six unidentified family members on January 1, 1940. They are standing in the front doorway of the Nash home at 1107 Gaston Avenue. Born in Waco, Nash came to Austin in 1927 to enter the car dealership business and eventually became president of Capital Chevrolet. His wife was vice president of the dealership. She received a degree in music and was president of the Austin Symphony Orchestra Society in 1958 as well as being active in numerous other civic organizations. (Courtesy of AHC/APL, C10797.)

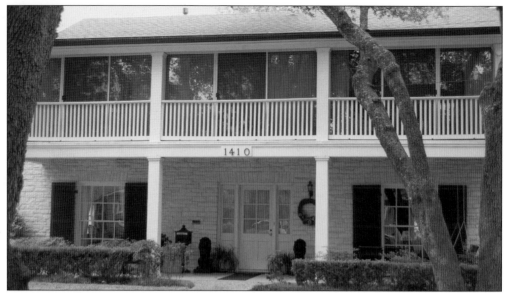

McCormick House. This home at 1410 Gaston Avenue was built in the early 1940s, with Bubi Jessen's firm serving as the project architects. Charles T. McCormick and his wife, Irline, were married in 1920 and took up residence here in 1944 after living at 1105 Claire Avenue. Irline McCormick was very supportive of her husband and was known for her gracious home. The McCormicks moved in 1961, shortly before Charles McCormick's death. (Photograph by Suzanne Deaderick.)

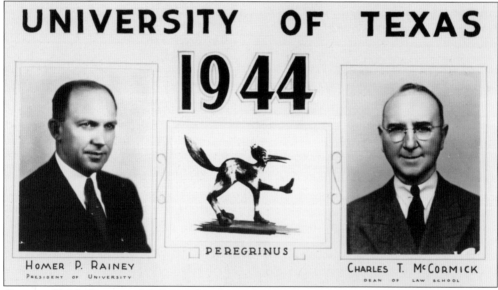

Charles T. McCormick. McCormick is shown here in 1944, the year he moved into the house on Gaston Avenue. He served as dean of the University of Texas School of Law from 1941 to 1949 and was a distinguished professor from 1949 to 1962. His personal prestige helped attract high-quality professors to the University of Texas. Dean McCormick wrote definitive textbooks on evidence, damages, and the federal courts and a large body of scholarly work. He was a gifted teacher and was known for his kindness. (Courtesy of Special Collections Department, Tarlton Law Library, University of Texas School of Law.)

THE ROGER WILLIAMS HOUSE. After joining the University of Texas, Williams founded the Biochemical Institute in 1940. While directing the institute for 23 years, Dr. Williams and his colleagues discovered more new vitamins and their variants than any other research group in the world. Dr. Roger and Phyllis Williams owned the house at 1604 Gaston Avenue for over 50 years. It is shown here in 1952. (Historic Landmark.) (Courtesy of Thea and Ricardo Wood.)

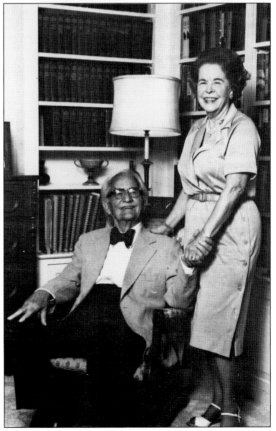

ROGER AND PHYLLIS WILLIAMS. An internationally known biochemist and nutritional scientist, Williams discovered pantothenic acid, a universal B-vitamin needed by every cell in the human body. He later concentrated folic acid for the first time and gave it its name. Roger Williams was a professor of chemistry at the University of Texas from 1934 until his retirement in 1971. In 1972, Dr. Williams was appointed to a panel by then president Richard Nixon to study heart disease. This photograph was taken about 1979. (Photograph by John Windsor/University Studio, published in *Austin Homes and Gardens*.)

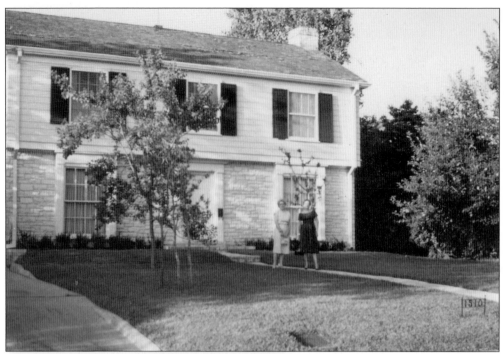

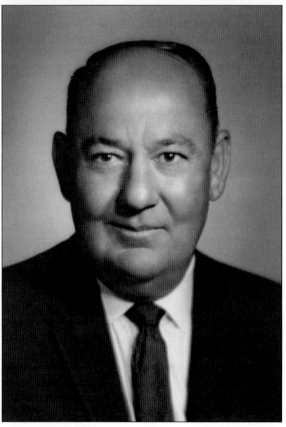

JACK CORLEY HOUSE. In 1941, Jack Corley purchased Thurlow Weed's funeral home and named it Weed-Corley. When Charles Whitman began shooting from the University of Texas Tower in 1966, Jack's daughter Julia recalls being on Guadalupe Street and seeing a man shot. Weed-Corley also had an ambulance business and took many of the victims to the hospital that day. The Corleys lived at 1510 Gaston Avenue. This undated photograph shows Charlie Miller (left) and Kathryn Roberts in front of the house. (Courtesy of Genie Miller.)

JACK CORLEY. Jack Corley's father, John R. Corley Sr., established a funeral home in Mexia, Texas, in 1878. Jack Corley came to Austin to attend the University of Texas before purchasing the Weed funeral home. His brother John R. Corley Jr. stayed in Mexia to run the family funeral home business there. (Courtesy of Carol Corley Nelson.)

FUNERAL OF LYNDON BAINES JOHNSON. A Texas military honor guard surrounds Weed-Corley Funeral Home on January 24, 1973, where the body of former Pres. Lyndon Baines Johnson was prepared for lying in state at the LBJ Library. The body was then taken to Washington, DC, for interment with full military honors. (Courtesy of AHC/APL, PICB19784.)

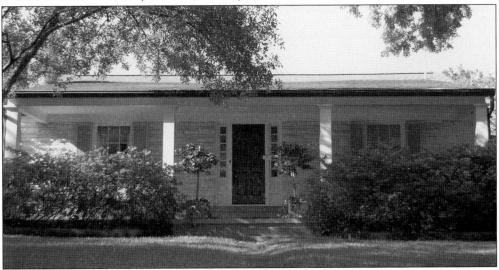

THE DAVIS HOUSE. Built in 1944, the house at 1600 Gaston Avenue remains in the Davis family to this day. Robert Davis organized the campaign of Waggoner Carr, who was successfully elected attorney general of Texas. He also served as legal representative for the state of Texas to the Warren Commission on the assassination of Pres. John F. Kennedy. Davis organized the national Students In Free Enterprise (SIFE) program, which is now active on over 1,500 college campuses. (Historic Landmark.) (Photograph by Suzanne Deaderick.)

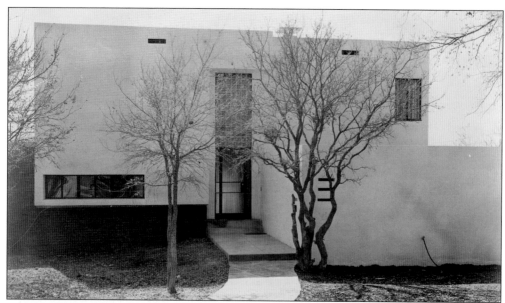

GEORGE WARD STOCKING HOUSE. Designed by Bubi Jessen and built in 1936 of reinforced concrete walls on a slab in the Art Deco style, this home at 1205 Gaston Avenue cost $13,000. Owner Dr. Stocking was a professor of economics at the University of Texas from 1924 to 1946. He worked on the National Recovery Act and authored numerous books on labor, competition, and economic controls. The home was remodeled in about the 1970s, eliminating the Art Deco features. (Courtesy of AHC/APL, PICH04941.)

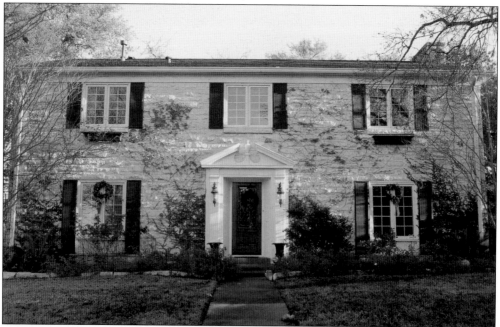

FIRST UNITED METHODIST CHURCH PARSONAGE. This home was built at 1612 Gaston Avenue in 1948. From its construction until 2002, it served as the home of pastors of the First United Methodist Church, located at Lavaca and Twelfth Streets in downtown Austin. The home is a good example of Colonial Revival architecture. (Historic Landmark.) (Photograph by Suzanne Deaderick.)

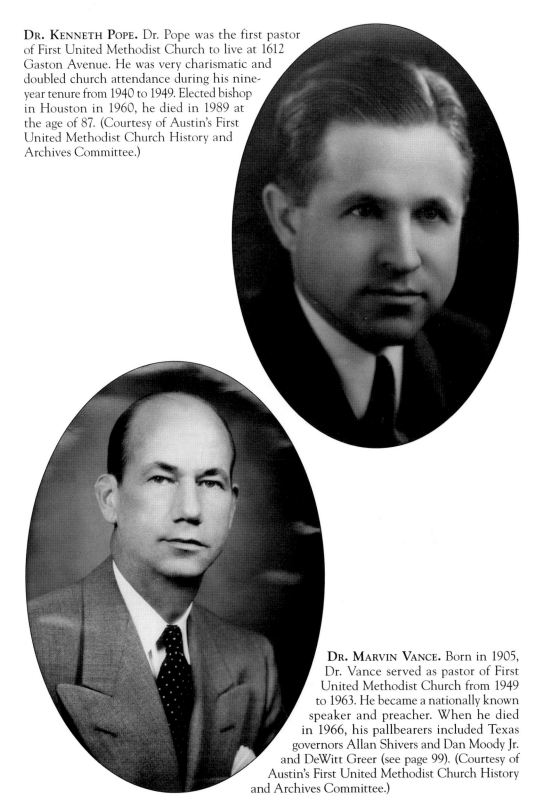

DR. KENNETH POPE. Dr. Pope was the first pastor of First United Methodist Church to live at 1612 Gaston Avenue. He was very charismatic and doubled church attendance during his nine-year tenure from 1940 to 1949. Elected bishop in Houston in 1960, he died in 1989 at the age of 87. (Courtesy of Austin's First United Methodist Church History and Archives Committee.)

DR. MARVIN VANCE. Born in 1905, Dr. Vance served as pastor of First United Methodist Church from 1949 to 1963. He became a nationally known speaker and preacher. When he died in 1966, his pallbearers included Texas governors Allan Shivers and Dan Moody Jr. and DeWitt Greer (see page 99). (Courtesy of Austin's First United Methodist Church History and Archives Committee.)

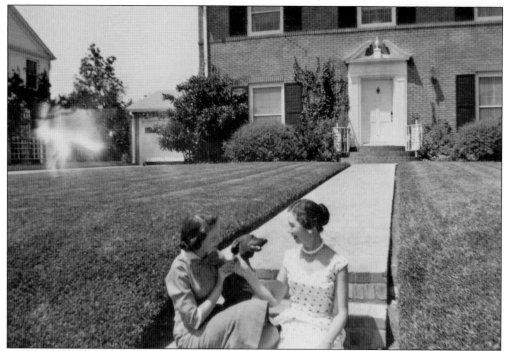

HOFMANN HOUSE. Designed by A.D. Stenger, this Georgian brick home at 1602 Gaston Avenue was built in 1954 for Bill and Pauline Hofmann. Pictured on the front steps in 1957 are daughter Suzanne Hofmann King, pet Juliana, and Pauline. Bill owned Hofmann Paint Company and had several patents for camouflage paint that contributed to US military efforts. Pauline became a home builder, collaborating with Stenger on a number of Austin homes. (Courtesy of Suzanne King.)

AUSTIN'S FIRST OFFICIAL MAYOR'S CAR. Roy Butler served on the Austin School Board for nine years before being elected mayor of Austin from 1971 to 1975. In addition to his service on the Austin City Council, Butler owned several businesses, among them a car dealership, a beer distributorship, and the KVET and KASE radio stations. Mayor Butler and his wife, Ann, lived at 1419 Gaston Avenue in the 1950s and 1960s. (Courtesy of AHC/APL, PICB11293.)

MILLER BLUE PRINT. Miller Blue Print was founded by John D. Miller in 1920 at 108 East Tenth Street. Miller spent many years as a draftsman in the Texas Highway Department, which taught him the importance of distortion-free reprographics. His goal was to provide this service on a handshake basis to small practitioners who could not afford the necessary equipment. In those days, sunshine was used to develop blueprints, which were dried on the store's rooftop. (Courtesy of AHC/APL, C06907.)

MILLER-PFENNIG HOUSE. Robert and Anna Miller commissioned Richard Erickson to design and R.G. Muller to build this home at 2401 Jarratt Avenue in 1950. Robert was the son of John Miller, who founded Miller Blue Print. Robert eventually took over the business. Robert's parents lived across the street at 2408 Jarratt Avenue. Robert and Anna lived in this home for 27 years and raised five children here. Arno and Lorraine Pfennig, who owned and operated an upholstery business, lived here for the next 19 years. This photograph is from about 1992. (Courtesy of Chuck Thompson.)

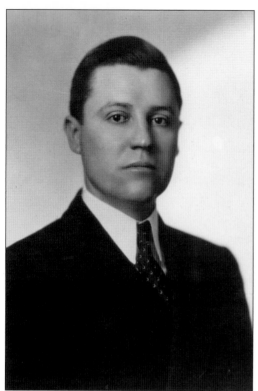

RALPH WEBSTER YARBOROUGH. Born in 1903, Ralph Yarborough was an attorney from Chandler, Texas. He was appointed to a state judgeship in 1936 and then ran unsuccessfully for state attorney general in 1938. After World War II service in the Army, Yarborough resumed his law practice in Austin. He ran for Texas governor three times, in 1952, 1954, and 1956. Finally, however, Yarborough was elected to fill a vacant US Senate seat in 1957. Lyndon Baines Johnson was the other Texas senator at the time. (Courtesy of AHC/APL, C09017.)

OPAL AND SON RICHARD YARBOROUGH. Ralph Yarborough and Opal Warren, both from Chandler, Texas, married in 1928. In about 1944, they moved into 2527 Jarratt Avenue. Opal Yarborough was the Travis County district clerk in the early 1940s. Later, she was held to be a gracious and supportive political wife. Opal and the Yarboroughs' only son, Richard Warren, are shown here in front of the family home, which was demolished in 2003, after Opal's death at the age of 99. (Courtesy of AHC/APL, PICB10058.)

2410 JARRATT AVENUE. Norman and Berdie Larson purchased the house at 2410 Jarratt Avenue in 1947 and lived there until the mid-1950s. Norman was a concrete contractor with Harold W. Larson & Son, general contractors. He and his son-in-law, Robert Pugh, organized Larson-Pugh, Inc., in 1957. Larson was active in the Texas Highway Heavy Division of the Associated General Contractors, serving as director and committee chairman. Norma Larson Pugh is shown standing in front of their car and house some time in the late 1940s. (Courtesy of Norman L. Larson.)

THE LOLLA PETERSON HOUSE. Lolla Peterson purchased the 1938 Tudor-style home at 2410 Jarratt Avenue in 1957 (photographed around 1947). Some called her "Godmother to the Poor," others said she was "practically a welfare agency in herself," and still others said she was "a fairy princess to the needy of Travis County." For almost 30 years, Lolla Peterson was connected with the Travis County Welfare Department, serving as director for many of those years. Lolla lived to be 90 years old. (Historic Landmark.) (Courtesy of Norman L. Larson.)

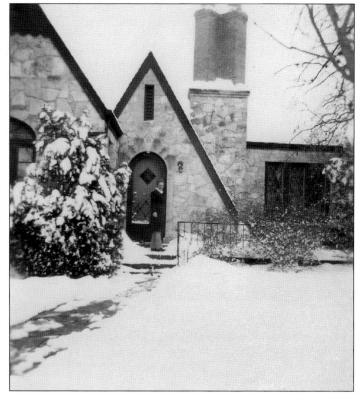

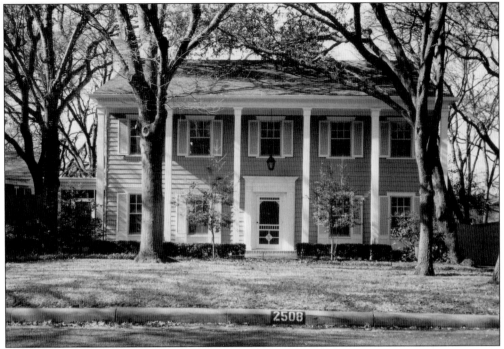

DeWitt Greer House. This Colonial Revival house at 2508 Jarratt Avenue was the home of Helen and DeWitt Greer. It was designed for them by Hugo Kuehne and built in 1936. The Greers lived there for 26 years. DeWitt Greer was described as "Texas's greatest servant" and "the father of the Texas highway system" for helping to transform Texas highways from muddy two-lane roads to the largest paved roadway system in the nation. The Greer house was demolished in 2003. (Courtesy of Ann Juul.)

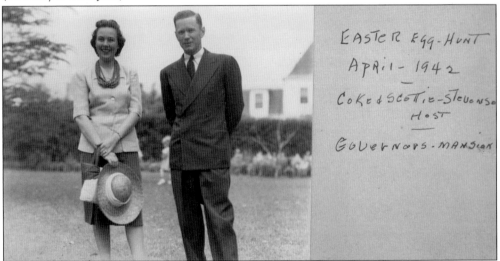

DeWitt and Helen Greer. The Greers attended an Easter egg hunt with their daughter Ann on the lawn of the Governor's Mansion in April 1942. Coke Stevenson was governor but left office to run for the US Senate against Lyndon Baines Johnson. Stevenson lost by 87 votes and the course of history was changed, as LBJ went on to become president of the United States. (Courtesy of Ann Juul.)

DeWitt C. Greer. In a career that began in 1927 and ended in 1980, Greer saw the number of miles of roadways in Texas jump from 20,000 to more than 67,000. In the 1950s, Greer helped inaugurate the development of interstate highways in Texas. The 1933 DeWitt C. Greer Building, which houses highway department offices at Eleventh and Brazos Streets, was named in his honor. (Courtesy of AHC/APL, PICB10748.)

Ann Greer Juul. The daughter of Helen and DeWitt Greer is shown standing in the front yard of her family's home at 2508 Jarratt Avenue. The photograph was taken in January 1947 and shows the house across the street at 2519 Jarratt Avenue in the background. That house was owned by Bryan Spires (see pages 78 and 79), president of Austin Goodyear Company, and later by John and Dortha Mahone. John was a loan manager at First Federal Savings Bank. (Courtesy of Ann Juul.)

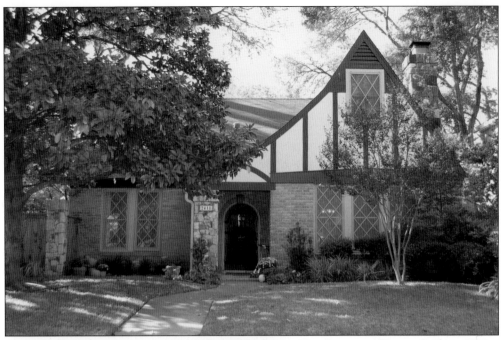

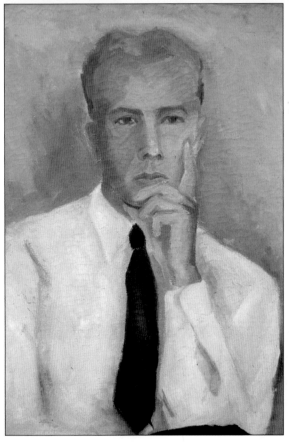

THE GARDNER HOUSE. Built in 1927 as the first model home in Pemberton, the house at 2418 Jarratt Avenue is referred to as "House No. 1" on the original blueprints. Judge J. Harris Gardner was elected district judge in 1941, a position he held for 20 years. He was also the county's first juvenile court judge. Gardner Betts Juvenile Justice Center is named in his honor. The Gardners owned the house for almost 60 years. (Historic Landmark.) (Photograph by Suzanne Deaderick.)

JUDGE GARDNER. When Gardner's young war bride, Claire Emillienne Porche, arrived in New York, she was not allowed off the ship because of her French citizenship. "I finally remembered that I had a letter from Gov. W.P. Hobby, who was then governor of Texas," said the judge. "I just took out that envelope with that great big gold Texas seal on it and she was off the boat in minutes. I've never seen red tape cut so quickly," he laughed. (Painting by unidentified artist; courtesy David and Robin Jackson.)

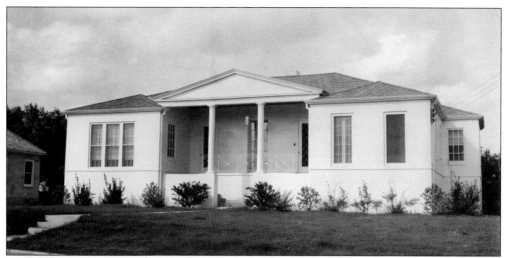

VICTOR BROOKS HOUSE. Designed by architect Glenn Wilson of San Antonio and built by J.D. Monk, the house at 1100 Claire Avenue was cast entirely of concrete. The approximate construction cost was $7,500. Owner Victor Brooks was president of Texas Concrete Products and was a pioneer in early prestressed concrete use in Austin. (Courtesy of AHC/APL, PICH04792.)

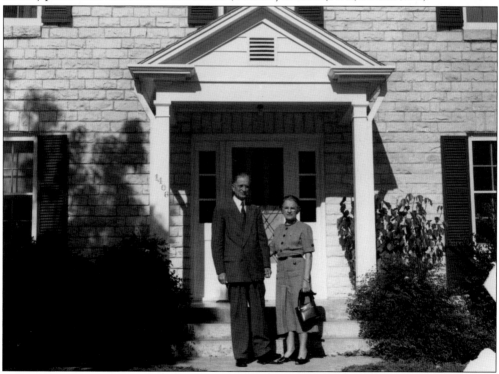

REV. EDMUND AND LOLLIE GRIMES HEINSOHN. From 1938 until 1960, Rev. Edmund Heinsohn and his wife, Lollie Grimes, lived in the University United Methodist Church parsonage at 1406 Ethridge Avenue, shown here. Austin's Most Worthy Citizen of 1958, Reverend Heinsohn served as chairman of the board of Huston-Tillotson College and trustee of Southwestern University for many years. He was known for his compassion, wisdom, and plain-spoken sermons. (Courtesy of AHC/APL, AR.1991.022[001].)

BROWNING AERIAL SERVICE. With the approach of World War II, Congress enacted civil aviation's greatest windfall—the Civilian Pilots Training Act of 1939. Shown here are Browning Aerial Service instructors in the World War II War Training Service program. The University Airport hangar in the background was one of the first modern airport hangars erected in the Southwest, and many famous pilots, including Amelia Earhart, are said to have landed there. The Brownings lived at 1512 Ethridge Avenue. (Courtesy of AHC/APL, PICA33416.)

NONCOLLEGIATE PILOTS TRAINING SCHOOL. Sponsored by the Austin Chamber of Commerce in 1939–1940, pilot training school graduates pictured are, from left to right, (second row) Emma Carter Browning, N.H. Wittner, R.B. Barnett, A.N. McCallum, and Max H. Bickler. Browning, the grande dame of Austin aviation, arrived shortly before World War II and was proprietor of Browning Aerial Service. (Courtesy of AHC/APL, PICA19598.)

Five

PRESTON AND OAKHURST AVENUES AND NORTHWOOD AND WESTOVER ROADS

WESTOVER, WOOLDRIDGE, AND CLAIRE. This January 25, 1940, photograph shows Wooldridge Drive heading north, Westover Road branching off to the west (left), and Claire Avenue branching off to the east (right). This is the southeast corner of the Edgemont subdivision at the north end of Pemberton Heights. (Courtesy of AHC/APL, PICA18184.)

2705 OAKHURST AVENUE. Milton S. Burney built this Tudor Revival home in 1935. Burney also erected four homes on Northwood Road, one on Westover Road, and others outside Pemberton Heights. His wife, Ida, was a real estate agent. The home was occupied successively by an engineer, a vice president of the Kerrville Bus Company, and the manager of the Austin Better Business Bureau, along with his wife, a scientist-engineer at the University of Texas. (Historic Landmark.) (Photograph by Suzanne Deaderick.)

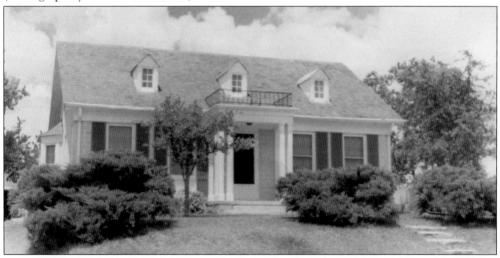

1400 PRESTON AVENUE. Nara and Lutie Ruth Carter were sisters who built this house (shown here in an undated photograph) in 1937. They had moved to Austin from Elgin. Nara worked for Scarbrough's for 63 years, while Lutie Ruth, known as "Peaches," worked for various lawyers. After they built this home, their parents came to live with them. Nara and Peaches's mother was known for the beautiful flowers she grew. Her roses and azaleas were featured in many Easter photographs of neighborhood children. (Courtesy of Nancy Green Abraham.)

1402 Preston Avenue. Plumbing contractor John W. Wattinger built this home in 1942. Wattinger's father, Jacob, was a Swiss immigrant and one of Austin's most prominent stone masons. The Wattingers worked on the construction of numerous city landmarks, including the Travis County Courthouse and the Austin History Center, as well as the University of Texas campus. The home was purchased in the late 1940s by the Joe Bland family. (Courtesy of Jo Ann Bland Finley.)

The Wattinger-Ginsburg House. Located at 1404 Preston Avenue, this house also was built by John W. Wattinger, in 1941. Wattinger's father, Jacob, founded the Wattinger Group, which is still in operation today. Sol and Anne Ginsburg lived in the house for over 25 years. Sol, co-owner of the Austin Man's Shop with Max Silberstein (see page 61), opened Michael's Men's Wear on Guadalupe Street in 1961. The store remained in business for over 20 years. (Historic Landmark.) (Photograph by Suzanne Deaderick.)

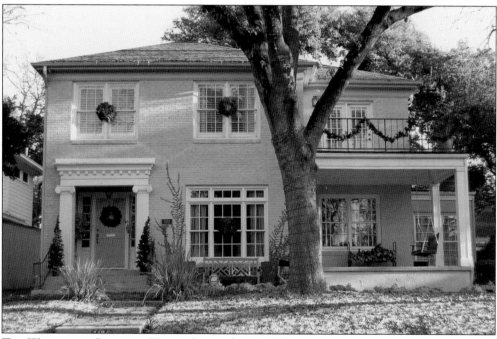

THE MARJORIE AND DEWITT REDDICK HOUSE. In 1941, DeWitt and Marjorie Reddick bought the Italian Renaissance Revival–style stucco house at 1511 Preston Avenue. Only four years old, the modest house was designed by noted architect C.H. Page and built in 1937 for Clark and Bessie Wright. Clark was a lawyer and division director for the Texas State Board of Control. (Historic Landmark.) (Courtesy of Alicia Helton.)

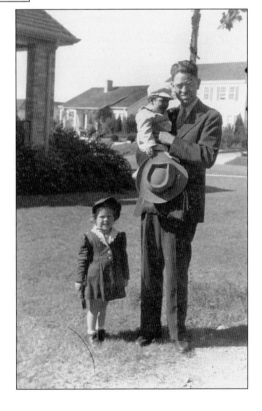

ALICIA, BRYAN, AND DEWITT REDDICK. Pictured here is Dr. Reddick with his daughter and son. Reddick became the first dean of the College of Communication at the University of Texas. One of the university's most effective teachers, Reddick taught thousands of journalism students, including Walter Cronkite, Lady Bird Johnson, and Ben Sargent. The Reddicks were married for 46 years. (Courtesy of Alicia Helton.)

MARJORIE ALICE BRYAN REDDICK.
Marjorie graduated Phi Beta Kappa
from the University of Texas in 1935.
In addition to being a great support
to her husband, Marjorie Reddick
volunteered for many civic and church
organizations. Dr. Reddick lived at
1511 Preston Avenue for 39 years
before his death at the age of 76.
Marjorie lived in her beloved house
for 59 years before her death at the age
of 89. (Courtesy of Alicia Helton.)

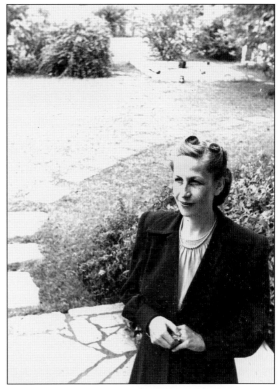

"LILA ANN." A lady known only as "Lila Ann" is shown cutting roses in the front yard of 1615 Preston Avenue, a house owned by the Lightfoots. The photograph was taken in 1945. Across the street are some of the newest houses in Pemberton Heights at the time. Note the lack of developed landscaping, because the land had been fields of corn and spinach just 20 years earlier. (Courtesy of AHC/APL, PICA29238.)

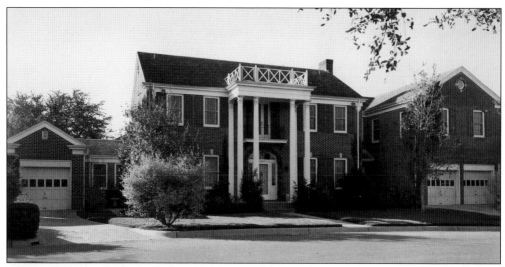

THE MASSEY-PAGE HOUSE. Designed by Page and Southerland and built by Weise Brothers in 1936, this home at 1305 Northwood Road has a fireplace mantle carved by Swiss woodcarver Peter Mansbendel (see page 120). It was one of his last pieces of work. Nelle and Holland Page purchased the house from the Masseys and lived here for 30 years. Page was one of the largest contractors in the United States from the 1940s to the 1960s. Carl and Karen Teel lived here for the following 29 years. Dr. Karen Teel was Austin's first female pediatrician, and Carl Teel taught piano to many children from their home. (Historic Landmark.) (Courtesy of AHC/APL, C05902.)

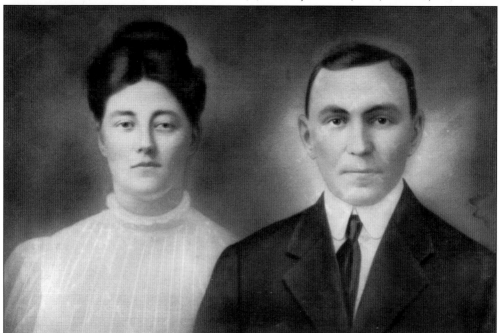

LUTHER AND DOSHA MASSEY. Luther Massey owned a very successful highway construction company that built part of historic Route 66 between 1919 and 1933. The house at 1305 Northwood Road was built with two separate garages, one with an apartment for nurses for when the Masseys grew old. However, Dosha was tragically killed before they even moved into their new home, and Luther and his young son lived here only a few years. (Courtesy of Kelly Mahmoud.)

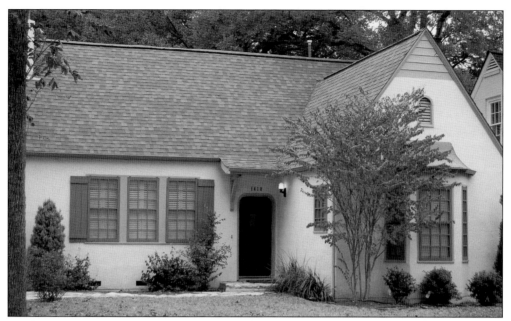

THE PARRISH-FLEMING HOUSE. Dallas architect Wilson McClure was the designer of 1410 Northwood, Road and this may have been his first commission. McClure later designed many homes in Dallas's Highland Park. The house was built by M. Clyde Parrish Sr. in about 1928 in the Picturesque or Romantic style, meant to evoke an English cottage. Parrish was a developer of the Edgemont subdivision, and his son and daughter-in-law, M. Clyde and Linda B. Parrish Jr. were among this home's first occupants. (Historic Landmark.) (Photograph by Suzanne Deaderick.)

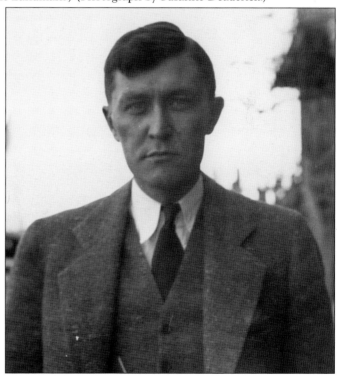

RAY EATON LEE. Ray Lee received a journalism degree from the University of Texas in 1925 and managed the *Austin American* newspaper in the mid-1930s. From 1938 to 1947, he served as Austin's postmaster, due to Lyndon Johnson's influence. After serving the US government abroad in Austria and Pakistan for several years, Ray returned to Austin in 1954, at which time he and his wife, Kathleen, purchased 1410 Northwood Road. (Courtesy of AHC/APL, PICB19313.)

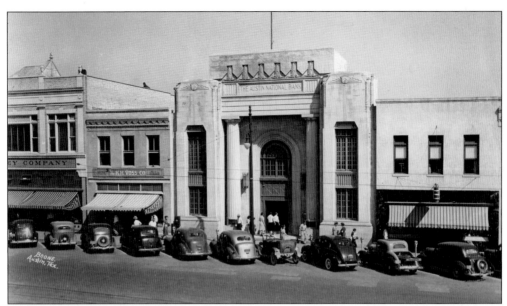

H.H. Voss Building. In September 1898, a New York paper announced, "H.H. Voss will soon open a china and glass store at Austin, Texas." Voss and Koock had the largest selection of Haviland and fancy china in Central Texas. H.H. Voss was the buyer for the firm. In 1932, he started the H.H. Voss Company. Pictured here is the store at 511 Congress Avenue. (Historic Landmark.) (Courtesy of AHC/APL, PICA02726.)

The Voss House. Around 1930, Herman F. Voss (son of H.H. Voss) began his career in Austin as a shipping clerk for Voss and Koock, a wholesale hardware store at 301 East Third Street owned by his father. Herman F. and Dorothy Voss had this Craftsman cottage built in 1930 at 1501 Northwood Road and lived here for about nine years before swapping houses with Herman's mother, Ida Voss. Ida lived here until her death in 1949. (Historic Landmark.) (Photograph by Suzanne Deaderick.)

1504 Northwood Road. Congressman Lloyd Doggett's parents lived here from the time he was born in 1946 until about 1960. Doggett's father was a dentist. Lloyd Doggett was a member of the safety patrol at nearby Bryker Woods Elementary School and claims that his public service began at that time. (Photograph by Suzanne Deaderick.)

Lloyd Doggett and Family. Lloyd Doggett is shown here with his wife, Libby; daughters Cathy (left) and Lisa; and dog Cotton on June 2, 1984, shortly before Doggett won a US Senate seat. Doggett's wife is director of a charitable trust, his daughter Lisa is an Austin physician, and his daughter Cathy, a former schoolteacher, now trains teachers. (Courtesy of AHC/APL, PICB19704.)

1505 Northwood Road. Built in 1936, this house was first owned by Marvin and Theo Mae Hall, whose daughter, Mary Pearl Williams, became the first female judge in Travis County. University of Texas professor Deupree Friedell and his wife lived here from 1942 to 1946, until they traded homes with Jack Myers, who lived on Wooldridge Drive. Jack Edgar Myers, well-known University of Texas professor, science editor of *Highlights* magazine, and award-winning science researcher, lived here with his family from 1946 to 1960. The photograph shows the snowfall of 1947. (Courtesy of the Jack Myers family.)

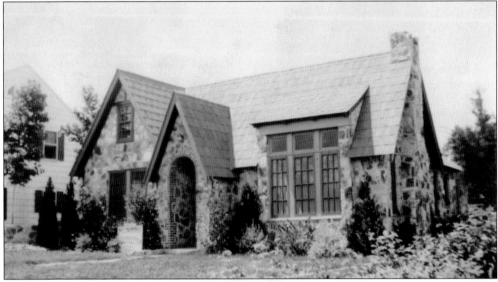

1507 Northwood Road. This July 27, 1936, photograph shows the home shortly after it was built. From 1937 until 1949, it housed several tenants, including the vice president of an asphalt company, an insurance agent, and a contractor. In 1949, John R. Cooke, a salesman, purchased the home. Around 1960, the home was acquired by Lavoisier Lamar, who was a professor from the University of Puerto Rico. (Courtesy of AHC/APL, PICH06582.)

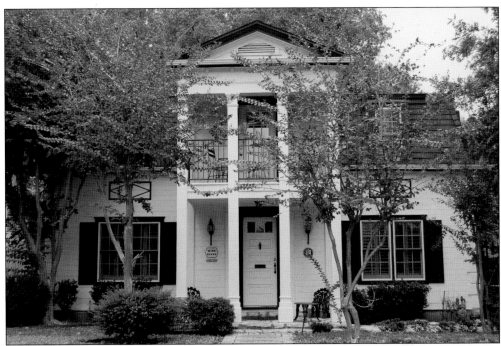

The McGee-Clark-Byrd House. Located at 1520 Northwood Road, this house was built by Vernon McGee (see page 33) in 1936 in a Southern Colonial Revival style with a mansard roof. Edward A. and Anne Metcalfe Clark bought the home in 1941. William Weldon and Rose Spacek Byrd purchased the home in 1951 and lived there for 47 years. Rose is an aunt of actress Sissy Spacek. (Historic Landmark.) (Photograph by Suzanne Deaderick.)

Ed Clark and Longhorn. Edward Aubrey Clark received a law degree from the University of Texas in 1928. He served as assistant attorney general of Texas before becoming an assistant to Gov. James Allred in 1935. He is shown here campaigning for Roosevelt in the 1930s. Clark was appointed Texas secretary of state in 1937 at the age of 30 and met Lyndon Baines Johnson shortly afterwards. In 1938, Ed Clark cofounded the Austin law firm of Looney & Clark, which eventually became Clark, Thomas & Winters, an influential Texas firm. LBJ and Clark became fast friends, and in 1965, Johnson appointed Clark as US ambassador to Australia. (Courtesy of AHC/APL, PICB01688.)

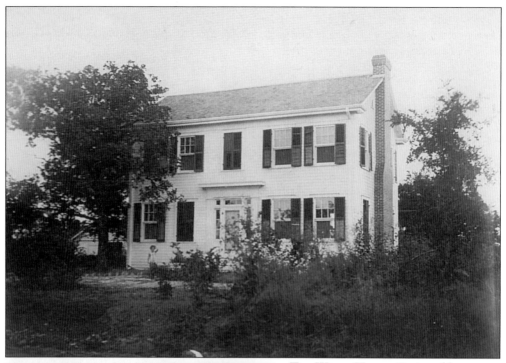

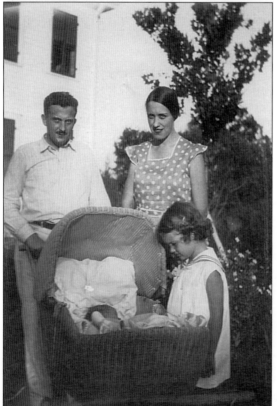

THE WEEKS HOUSE. Designed by Arthur Fehr, a young architect in need of work, the house at 1606 Northwood Road was the dream of Oliver Douglas Weeks. Professor Weeks wanted his home modeled after Abraham Lincoln's home in Springfield, Illinois, which it does in fact closely resemble. This photograph was taken in 1934, the year the house was built. (Courtesy of J. Dev Weeks.)

PROFESSOR WEEKS AND FAMILY. Oliver Weeks, an authority on American, Southern, and Texas politics, was a government professor at the University of Texas and chairman of the government department on and off from the 1930s through the 1950s. His wife, Julien Elizabeth Devereux Weeks, had the front door of their home designed to resemble the front door of her ancestral home, the Monte Verdi Plantation in Rusk County, which was a successful cotton plantation of over 10,000 acres. (Courtesy of J. Dev Weeks.)

James and Zella Pope. This 1949 photograph shows James G. Pope Jr. and his wife, Zella Schultz Pope. James worked in the Texas State Comptroller's Office, and Zella gave elocution lessons and later worked for the state. Zella's mother deeded them the lot at 1315 Westover Road as a wedding gift. The couple built the home that still stands there and is now inhabited by their granddaughter, Katherine Brown, and her family. (Courtesy of Katherine Mosley Brown.)

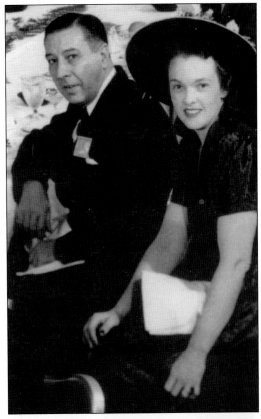

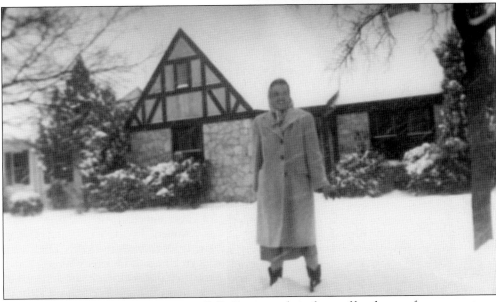

Big Snow at 1315 Westover Road. Zella Pope stands in front of her home after a snowstorm in the late 1940s. James Pope died approximately 10 years later, in 1957, but Zella lived in the house until her death in 1987. The house has kept its original appearance. (Courtesy of Katherine Mosley Brown.)

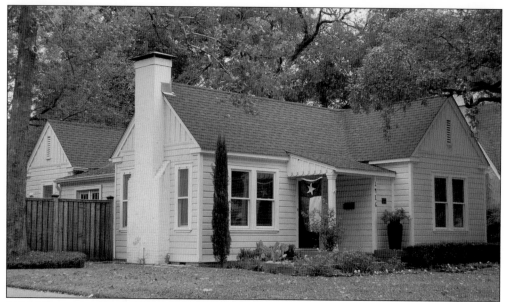

1416 WESTOVER ROAD. This wooden bungalow was built in 1937 by Richard Schermerhorn Rowe. Rowe was a 1931 graduate of the University of Texas and earned his master's degree from the Massachusetts Institute of Technology in 1933. He also received a medal from the American Institute of Architects for the excellence and originality of his work. Rowe was trained as a draftsman and artist and presumably designed the home. He leased it until selling it in 1958. (Photograph by Suzanne Deaderick.)

THE CULLERS-ADKINS HOUSE. A typical Edgemont cottage, the house at 1515 Westover Road was built in 1938. Elsie and Elmer Cullers, both teachers, owned the house for 15 years. In 1959, Thomas and Jean Adkins bought the house. Jean was a schoolteacher for over 24 years. Dr. and Mrs. Adkins came to Austin in 1959 and opened a dental practice. Dr. Adkins was renowned for never turning away a patient who needed dental care. He worked at the Scarbrough Building and was its longest tenant, from 1960 to 2006, when he retired at the age of 89. (Historic Landmark.) (Courtesy of Thomas and Jean Adkins.)

Six.

ARCHITECTS, ARTISANS, BUILDERS, AND SUPPLIERS

HUGO FRANZ KUEHNE.
Architect Hugo Kuehne
was an important part of
Austin's development from
the 1920s to the 1950s and
also designed many houses
in Pemberton Heights. He
was the founding dean of the
University of Texas School
of Architecture. In 1954,
Kuehne was named Austin's
Most Worthy Citizen in
recognition of his 31 years
of service on various Austin
planning, zoning, and park
commissions. (Courtesy of
AHC/APL, PICB13477.)

ENFIELD GROCERY. In 1916, architect Hugo Kuehne designed the Enfield Grocery, located at an easy distance southeast of Pemberton Heights on Lamar Boulevard. It was modeled on a German public house, and Peter Mansbendel added elaborate carvings to the eaves in 1934. The grocery store became a steak restaurant and a covert speakeasy during Prohibition. This building today is known as the Tavern. (Courtesy of AHC/APL, PICH06752.)

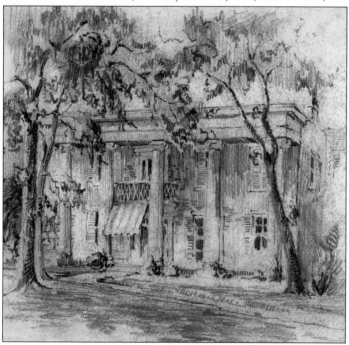

J. ROY WHITE SKETCH. The Pease Mansion, also known as Woodlawn, is depicted in this sketch by architect and artist Roy White. (Compare this to the photograph on page 9.) White received his degree in architecture from the University of Texas in 1929. He supervised the restoration of Lyndon Johnson's boyhood home in Johnson City and the LBJ State Park complex, serving almost as the Johnson family's personal architect. He also designed homes for Pemberton Heights. (Courtesy of AHC/ APL, PICH10226.)

CHARLES H. PAGE. Architect Charles Page both lived in Pemberton Heights and designed many of its homes in a variety of architectural styles. Page and his wife, Miriam, built their home at 4 Green Lanes in Pemberton Heights in 1938. This photograph shows Page in November 1949. Page died eight years later, leaving his practice, then called C.H. Page & Son, to Charles H. Page Jr. (Courtesy of AHC/APL, PICB19315.)

PAGESOUTHERLANDPAGE OFFICE. Charles Page formed a professional partnership with Louis Southerland in 1898, and they designed many public buildings, including the Art Deco–style Travis County Courthouse, Austin's Littlefield Building, and the Austin National Bank Building. This undated photograph shows office staff at the firm of PageSoutherlandPage, which is still in existence. (Courtesy of AHC/APL, AR.2009.29[CHP-221], and Paralta Studios.)

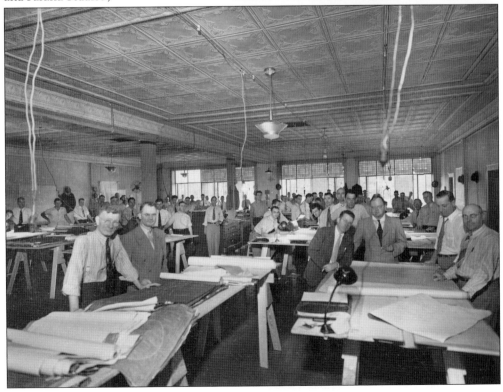

PETER MANSBENDEL. Peter Mansbendel was born in Switzerland in 1883. At the age of 10, he knew he wanted to become a woodcarver. He trained in Switzerland, London, and Paris before working in Boston and New York. While in New York, he met Clothilde Shipe, the daughter of Col. Monroe M. Shipe, who developed the Hyde Park neighborhood in Austin. They married in 1911, and Mansbendel opened a studio in Austin. (Courtesy of Doug Oliver.)

MANSBENDEL CARVING. During the 1920s and 1930s, leading architects in Austin, Dallas, Houston, and San Antonio sought Mansbendel to provide a carving, such as this example, that would add a touch of distinction to their projects. Several Pemberton Heights homes have Mansbendel carvings. He also provided carved doors for the Spanish Governor's Palace in San Antonio and portrait medallions for the University of Texas. (Courtesy of AHC/APL, C11068.)

FORTUNAT WEIGL. Lured by cowboy stories of the Wild West and the hope of a better life, ironworker Fortunat Weigl, his wife, Anna, and their two sons left Germany for Galveston in 1913. In 1922, Weigl met Peter Mansbendel, who asked him to create iron fixtures for a project, so the Weigl family moved to Austin and opened the Weigl Iron Works. This photograph shows Weigl with his iconic tools. (Courtesy of AHC/APL, PICB09639.)

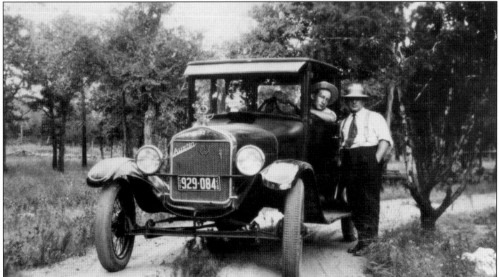

FORTUNAT AND LEE WEIGL. Weigl had two sons, Lee and Herbert, also ironworkers. Their smithy was located at the current-day site of Iron Works BBQ on Red River Street. This photograph shows Lee (driving) and Fortunat Weigl. Weigl craftsmanship adorns many buildings in Austin, including the state capitol and Laguna Gloria Art Museum, as well as some Pemberton Heights homes. (Courtesy of AHC/APL, PICB09644.)

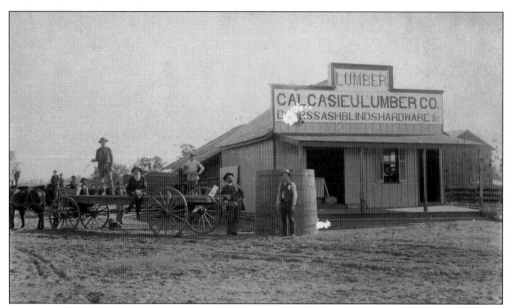

CALCASIEU LUMBER COMPANY, EARLY PHOTOGRAPH. In 1883, William and Carl Drake founded Calcasieu Lumber Company, with a one-room location near the Colorado River at Second and Guadalupe Streets. They sold high-quality pine from Calcasieu Parish, Louisiana, known for its excellent lumber, some of which ended up in Pemberton Heights homes. The Drakes had one of the first lumberyards to offer delivery service, shown here. (Courtesy of AHC/APL, PICA05339.)

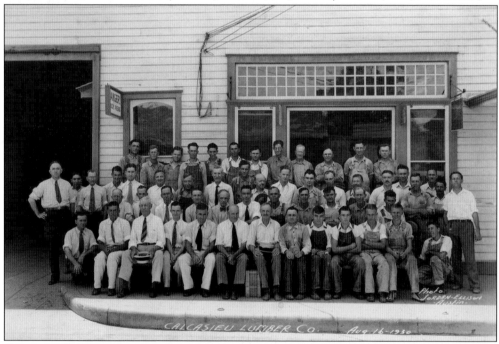

CALCASIEU LUMBER COMPANY EMPLOYEES, 1930. By 1930, the company had expanded to fill four city blocks and had numerous employees. Founder William Drake is in the front row, third from the left, holding his hat. Throughout the Great Depression, not one Calcasieu employee was dismissed or had his salary reduced. (Courtesy of AHC/APL, C08964.)

CALCASIEU LUMBER COMPANY PICNIC, 1934. William Drake died in 1934, shortly before the post-Depression building boom. The Drake family and many dedicated employees kept the business going. The gathering of employees in this photograph took place in Zilker Park and includes future Austin mayors Bill Drake and Lester Palmer as teenagers. (Courtesy of AHC/APL, PICA07801.)

CALCASIEU LUMBER COMPANY WAREHOUSE. Calcasieu stenciled the company name on its lumber, and Pemberton Heights residents remodeling their homes have uncovered boards marked with the Calcasieu name. The company produced house plans for home buyers, also providing materials and labor for construction. In 1916, Calcasieu made installment plans available for financing home construction, helping fuel a building boom in Austin in the 1920s. (Courtesy of AHC/APL, PICA02879.)

BUTLER BRICK CABLE BUCKETS. Elgin Butler Brick and Tile Company bricks were used in building many Pemberton Heights homes. Michael Butler emigrated from Ireland and founded the company in 1873. This photograph shows cable buckets transporting clay for bricks from a location in current-day Zilker Park to the brickworks, which was then located across the Colorado River at the current site of Steven F. Austin High School. (Courtesy of AHC/APL, PICA10623.)

BUTLER BRICK KILN. Colorado River clay, manual labor, wooden molds, and updraft kilns produced "Austin commons" brick, which showed colors such as buff, yellow, red, and brown. Elgin Butler Brick advertised, "Color's the Thing, Brick the Medium." Millions of Butler bricks were used to build the capitol and the University of Texas. This undated photograph shows the kilns, burning foreman, and two employees. (Courtesy of AHC/APL, PICA25224.)

BUTLER BRICKYARDS. In 1942, the Butler Brick plant in Austin became subject to World War II price freezes. The plant was demolished in 1958, and the land eventually was acquired by the Austin Independent School District. However, back in 1903, Michael Butler had established another brick plant east of Elgin, Texas. This July 24, 1957, photograph shows the brick storage yards of the Elgin plant. (Courtesy of AHC/APL, PICA25222.)

TIPS IRON AND STEEL COMPANY. Tips Iron and Steel was founded in 1899 by Walter and Eugene Tips and others. In 1909, they moved to Third Street at Lamar Boulevard. By 1936, the company was 10 times larger than when it started. Tips supplied structural support beams for buildings such as the Driskill Hotel, the Austin History Center (then the Austin library), and some Pemberton Heights homes. (Courtesy of AHC/APL, C05483.)

TIPS COMPANY PICNIC. These two photographs appear to be of a company picnic, with one showing the facade of the Tips Iron and Steel Building and the other taken from the roof of that building, showing the picnic spread and the surrounding neighborhood. Inside, the cavernous building had a wooden floor, and along the length of the building were machines, parts, boxes of supplies, and partly fabricated projects. At noon each workday, the company blew a whistle audible for blocks, signaling the workers that they could stop for lunch. The abandoned building stands today at Third Street and Baylor Street, along the railroad tracks and across from the Amtrak station. (Above, courtesy of AHC/APL, C10843; below, courtesy of AHC/APL, C10844.)

INDEX

Discover Thousands of Local History Books
Featuring Millions of Vintage Images

Arcadia Publishing, the leading local history publisher in the United States, is committed to making history accessible and meaningful through publishing books that celebrate and preserve the heritage of America's people and places.

Find more books like this at
www.arcadiapublishing.com

Search for your hometown history, your old stomping grounds, and even your favorite sports team.

Consistent with our mission to preserve history on a local level, this book was printed in South Carolina on American-made paper and manufactured entirely in the United States. Products carrying the accredited Forest Stewardship Council (FSC) label are printed on 100 percent FSC-certified paper.